Edward Bawden's
England

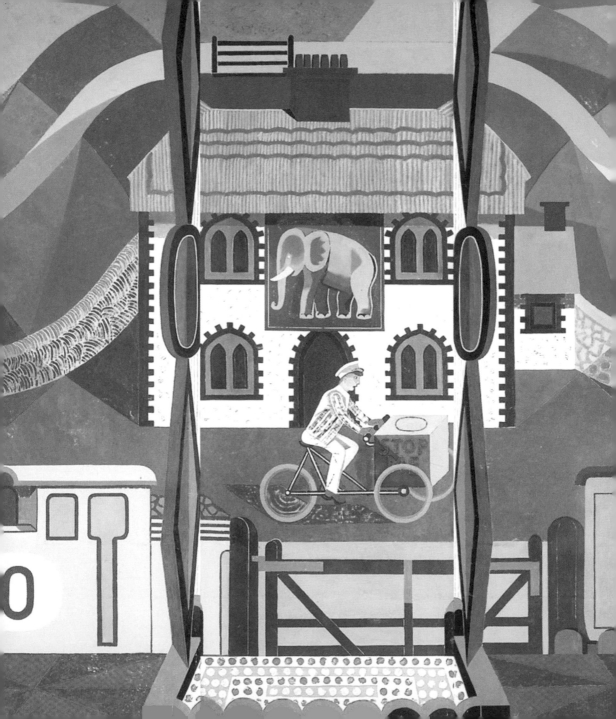

Edward Bawden's England

Gill Saunders

Contents

Preface

Edward Bawden (1903–1989) enjoyed a long life and a prolific and varied career, but the first full retrospective of his work was not staged until 1988, a year before his death, at the Kent Institute of Art & Design. This transferred to the Victoria and Albert Museum the following year, when there was another big exhibition at the Higgins Art Gallery & Museum, Bedford, to which Bawden had recently donated the contents of his studio. Examples of his watercolour painting, textiles, wallpapers, illustrations, posters and designs of all kinds were by then already in museum collections, including the Tate and the V&A, and he had been the subject of a BBC profile in 1963 (as part of the *Monitor* series), but his name was otherwise little known to a wider public, and only in recent decades has his reputation – along with that of his good friend and fellow artist Eric Ravilious (1903–1942) – enjoyed a significant revival. In part this earlier neglect can be attributed, perversely, to the extraordinarily wide range of Bawden's creative activity, and his refusal to distinguish between fine art and commercial design. This was compounded by his resistance to being categorized – he adopted no 'ism', belonged to no 'School' and doggedly ploughed his own furrow.

Aside from the years he spent in France, the Middle East and North Africa while serving as a war artist in the 1940s, and later visits to Canada and Ireland, Bawden rarely travelled far from home, but found inspiration in the fields and farms of his native Essex, at the seaside, and in classic London scenes: Kew Gardens, the Royal Parks, the Tower of London and St Paul's Cathedral,

Fig. 1 *Knole Park*, wallpaper, printed
and published by the Curwen Press, 1929
Colour lithograph after linocut original
Victoria and Albert Museum, London
(V&A E.960-1978)

and the iron-and-glass monuments to Victorian engineering
such as Liverpool Street station and the markets in Spitalfields
and Smithfield. As this book demonstrates, it was England, with
its quiet landscapes, its pleasures and pastimes, its history and
ceremonies, its traditions and recreations, that was the source
of his finest and most engaging work.

Introduction

'[A] certain part of Essex is by comparison a landscape painter's paradise ... We know what to look for – a rabbit flick, the scurry of a stoat, primroses in ditches, or dog roses in hedgerows ...'[1]

Bawden wrote this on 16 February 1942 in a letter home to his friend Eric Ravilious, when he was stationed in Ethiopia in his capacity as an official war artist. Weeks spent in the relentless heat of the desolate desert landscape made him yearn for the cool, green places of England and his home in Essex in particular. His attachment to the landscape of this county was pronounced and lifelong. In August 1930, writing to friends from his student days, he eulogized the pleasures of the Essex countryside: 'where the thistles grow tall & juicy, & the green grass is long, tender & sweet ... grasshoppers sing in the noonday heat & thirsty flies buzz & procreate in the dew laden flowers'.[2]

Bawden was born in Braintree, and aside from his time in London as a student and his years abroad during the war, he spent most of his adult life in Essex, first in Great Bardfield and later in Saffron Walden, travelling very little – although painting holidays to Sussex, Cornwall and Shropshire, often in the company of artist friends, yielded some fine watercolours.

Bawden discovered the pretty village of Great Bardfield, which was to be his home for 40 years, in 1931, when he and Ravilious were cycling around the county looking for a place to stay while they painted watercolours of local scenes. They ended up renting Brick House, a handsome Georgian property on the High Street, and when Bawden became engaged to Charlotte Epton, a student with him at the Royal College of Art (they married the following year), his father purchased the house for the couple as a present.

Fig. 2 Jorge Lewinski (1921–2008)
Edward Bawden at work in
his studio, 1963
Photograph
Victoria and Albert Museum, London
(V&A 492-1965)

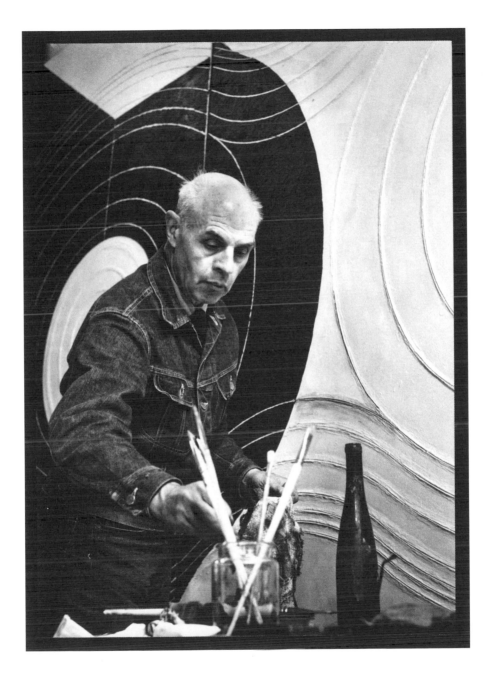

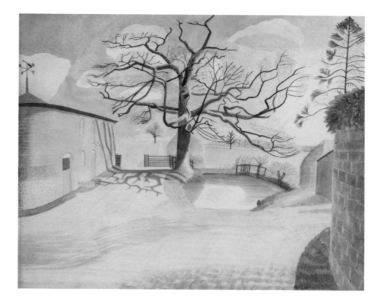

In due course Great Bardfield became a lively artistic community, an English 'Montmartre' as one reviewer of their 'open house' exhibitions later described it.[3] As a result of his enthusiastic encouragement Bawden was joined there by many other artists and designers: John Aldridge; Ravilious and his wife, Tirzah Garwood; and later Kenneth Rowntree, Michael Rothenstein and several others, including some of Bawden's former students from the RCA, such as Sheila Robinson and Walter Hoyle. Brick House, and its garden, appear in many of Bawden's watercolours, and village views abound in his paintings, prints and illustrations. The scene of his watercolour painting from 1933 of a leafless tree and a barn beside the village pond (fig. 3), with the cryptic title *Turning while your bones last* (a view of Bluegate Hall Farm), had first appeared in print – garnished with a horse-drawn hay wagon, hens, ducks and a pig – as an illustration for April in Ambrose Heath's cookery book *Good Food* (1932). The illustration for May included Bawden

himself, with Eric and Tirzah and their friend Thomas Hennell lunching in the shade of a tree in the garden at Brick House.

Bawden's talent and enthusiasm for drawing had become apparent at an early age, and he became a full-time student at the Cambridge School of Art from the age of 16. He specialized in industrial design, and in 1922 he won a scholarship to the Design School at the Royal College of Art in London. At the time the RCA was housed in buildings attached to the V&A, with a connecting door on a staircase between the two, and Bawden made much use of this proximity: 'I mooned around the V&A daily, worked in the library ...'.[4] However, he quickly came to resent the low esteem accorded the Design School ('the habitat of the lowest of the low'[5]) by comparison with the schools of painting, sculpture and engraving, although the principal, William Rothenstein, promoted an Arts & Crafts ethos that treated artists and designers as equals, an approach supported by Bawden's tutors Robert Anning Bell and Professor E.W. Tristram.

Bawden himself made no distinction between his roles as an artist and as a designer. In his view this was an artificial separation maintained 'by the dealers for commercial reasons'.[6] Throughout his career he moved seamlessly between painting, printmaking and what we might call design work; the last included commissions for commercial clients such as London Transport and the Curwen Press, and for various manufacturers and retailers wanting illustrations and promotional material. He also designed for industry, producing objects that included ceramic tiles, furnishing textiles, a biscuit tin and a garden bench, described by its manufacturer as 'an ornamental seat unique in its gracefulness'.[7] At the same time he continued to work independently, painting watercolours and making prints. When asked in 1982, 'have you gradually stopped being a designer to become an artist?', he responded, 'But there's no difference between one and the other. All my life I've been intermittently doing watercolour drawings, and I've been interested in line engravings, lithographs and lino-cuts.

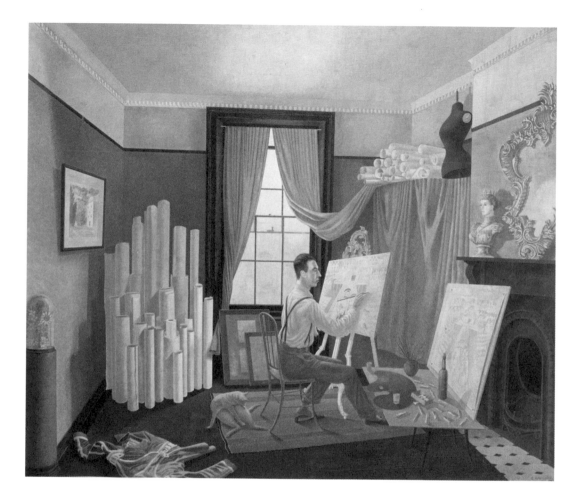

Fig. 4 Eric Ravilious (1903–1942)
Edward Bawden Working in
*his Studio, c.*1929–30
Tempera on board
Royal College of Art, London
(RCA_CC_14)

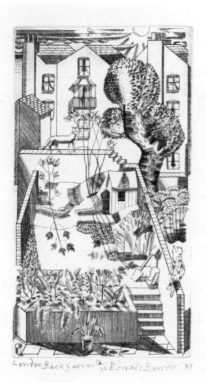

London Back Garden, Edward Bawden '88

Fig. 5 *London Back Garden*,
1927, restrike, printed 1988
Etching
British Museum, London
(1987,1212.14)

I turned my interest to any direction.'[8] This dual identity was recognized with appropriate accolades: Bawden was made a Royal Designer for Industry in 1949 and elected to the Royal Academy in 1956.

Despite his criticism, the RCA was to be hugely influential for Bawden, thanks to tutors from backgrounds in craft and industry, and in particular the teaching of Paul Nash (1889–1946), a painter who was also a successful designer. Nash had Bawden and his peers in mind when he later said, 'Ten years ago I was teaching at the Royal College of Art. I was fortunate in being there during an outbreak of talent.'[9] This talented group also included Ravilious, another scholarship boy whom Bawden met on his first day at the college. Despite their very different temperaments – Ravilious lively and outgoing, Bawden shy, taciturn and reserved – they became fast friends and were to remain so until Ravilious's untimely death in 1942. They shared student lodgings at 58 Redcliffe Road, Chelsea; the house and more particularly its garden were the subjects of one of Bawden's earliest prints, an engraving titled *London Back Garden* (fig. 5). Packed with quirky picturesque minutiae that conjure a very particular spirit of place, this print is typical of Bawden's careful, somewhat laboured engravings of this period. He gave a unique hand-coloured impression to Ravilious as a memento of their time lodging there.

From the first, Bawden and Ravilious found common cause and worked together. A portrait by Ravilious, *Edward Bawden Working in his Studio*, shows Bawden in his studio at 52 Redcliffe Road (a few doors down from his original student lodgings), at work on an oil painting of a couple on Clacton Pier, and surrounded by a miscellany of objets d'art (fig. 4). As Tirzah Garwood later recalled, Bawden 'collected military uniforms and hats of various kinds',

with a hat stand for the hats and a tailor's bust for the uniforms, and 'he had a fine Victorian ornamental piece, a dish of fruit and flowers made out of wax and beads which was covered with a large glass dome – he was one of the first people to fully appreciate such pieces at that period.'[10] Also prominent in the picture are many rolls of paper, preparatory studies for the mural at Morley College for Working Men and Women in Lambeth, which was to be Bawden and Ravilious's first joint endeavour. With fellow student Charles Mahoney, they decorated the Refreshment Room with scenes of Elizabethan theatre, to which Bawden contributed several scenes from Shakespeare's plays. With its doll-like figures, the mural was whimsical, comic and playful. It opened to great acclaim in 1930, after two years' work, but was destroyed when the building was bombed in 1940. In 1958 Bawden painted a replacement, based on *The Canterbury Tales.*

Nash also introduced Bawden to Frank Pick (1878–1941), then the mastermind responsible for the design of every aspect of the London Underground,[11] from its stations to its maps and time-tables. Pick first commissioned Bawden to design a poster map

of the 1924 British Empire Exhibition (1). It was a daunting project for an untried artist who was then still a student, and Bawden struggled with it and filled it in with such a profusion of lively incident that it was probably of little use for directing visitors, although it certainly demonstrated the variety of the attractions to be found within. Further poster commissions followed, and Bawden gradually moved from the bright picture-book style that characterized *Changing the Guard* (6) and *Hyde Park* (both 1925) to simpler, bolder graphics (inspired by the work of Claud Lovat Fraser, and that of Edward McKnight Kauffer, whose striking London Underground posters Bawden collected) that were better suited to the poster format. Working with collage and linocut, Bawden produced a number of distinctive designs, which were reproduced lithographically. These included posters promoting Hyde Park, Regent's Park and Kew Gardens. More conventional were the linocut pair posters advertising day trips to the home counties, where he used a wallpaper-like pattern as a foil to the vignettes of historic houses.

Bawden's work is characterized by its singularity, its very personal vision, which drew on several distinctively English traits: the Romantic landscape vision of Samuel Palmer in his Shoreham phase (fig. 6); the tradition of landscape watercolour

painting itself (he particularly admired Francis Towne and John Sell Cotman); the engaging eccentricity of Edward Lear's humorous drawings; the stylized black and white of Aubrey Beardsley's drawings for *The Yellow Book* (fig. 7) and *The Studio*; and popular ephemera such as posters and book illustrations. An abiding affection for Victoriana gave a nostalgic flavour to some of Bawden's designs, but his lively wit always lifted them from pastiche.

Landscape watercolours

Since the mid-eighteenth century painting in watercolour has been considered a quintessentially English art. Writing in 1934, the critic and painter Adrian Bury eulogized the English watercolour tradition, describing it as being 'as national as the language itself, as much a part of England as her contours and climate'.[12] Reviewing Bawden's first solo show of paintings, at the Zwemmer Gallery, London, in 1933, the art critic of *The Times*, Charles Marriott, described his pictures as having 'a surprising flavour, like that of watercress'[13] – a metaphor that neatly captures something of the freshness and originality of Bawden's work as well as his essential Englishness of style and subject. Marriott also noted Bawden's willingness to shape his own response 'to the native landscape instead of forcing it into a foreign mould'.[14] Certainly, he loved the lush greenery of the English landscape, and the sturdy individuality of its barns and parish churches, but his work is never smooth or facile, nor is it simplistically nostalgic or sentimental. Like watercress, it has bite and character.

This view of Bawden's painting is also found in other contemporary comments. *The Observer*'s reviewer praised the 'enviable freshness of vision and poetic imagination' in rendering 'the most commonplace of cottages, barns, backyards, village streets and country roads'.[15] His friend Douglas Percy Bliss, reviewing the same exhibition, declared that despite an apparent affinity with those contemporaries affecting 'a child-like innocence of vision', Bawden

> is no false 'naif'. His vision of the world is not so much child-like as narrow and detached. It is, withal, intensely individual and highly humorous … He looks around his Essex landscapes wide-eyed and eagerly, but he sees it as no one else would … preternaturally bright and clean and colourful.[16]

Bawden's watercolours of the 1930s – Essex landscapes titled with lines of English poetry,[17] and later Sussex views named for the month and time of day when they were painted – are characterized by a technical approach described by the critic Eric Newton in 1938 as

> neither slick nor charming nor fresh. They are dry and worried and patchy. But they are immensely serious. They break the rules because Bawden cares less for the rules than for the things he has to say about the feel of a summer morning, the watery sunshine of an April afternoon, or the flurry of a February snowstorm.[18]

This same feeling for atmosphere and spirit of place can be seen in the painting of Walton Castle that was reproduced as a Shell poster in 1936 (**33**).

Bawden's later work in watercolour is looser, reflecting the experience of painting in the heat of the Middle East, where of necessity he worked fast, using more fluid pigments, because the paint dried so quickly. This greater fluency can be seen in the pictures he painted in Cornwall and in Shropshire in the 1950s. Commenting on an exhibition of his war work at the Imperial War Museum, London, in 1983, he said, 'I can trace a development in the work from stiff simple drawings to late ones that are rather dashing, more accomplished, the medium used more flexibly and fearlessly.'[19]

Bawden continued to paint watercolours after the war, but his figurative style was by then considered rather old-fashioned – and so indeed was the use of watercolour itself – so in the late 1940s he concentrated his efforts on commercial work. This included murals, book jackets, illustration and posters. He also made a number of strikingly original linocut prints, which attracted a new audience and sold well.

Bawden returned to watercolour in the 1970s, with several fine pictures of the trees and parkland at Audley End (near Saffron Walden, where he was then living). In the 1980s, towards the end

of his life, he sought subjects closer to home, and produced many domestic interior views, all featuring his beloved cat Emma Nelson, who, by his account, chose the settings. As he explained to a friend, 'I just watch her, and wherever she settles, that's what I paint.'[20]

Life in an English Village

This little book was not a commission, but a project that Bawden himself suggested to the publisher. He had perhaps been inspired by the success of Ravilious's pre-war picture book *High Street* (1938), which recorded the interiors or shop windows of every kind of retailer from furrier to fireworks seller. In 1949 Penguin published Bawden's series of 16 colour lithographs as *Life in an English Village*, an affectionate but clear-eyed account of daily life in Great Bardfield (48–59). The black-and-white illustrations and the cover artwork are all suggestive of a cottage parlour of the old-fashioned style in which people still lived with the furniture and ornaments of earlier generations – as did Bawden himself. Like Bawden's collections of Victoriana, the book may now seem a nostalgic curiosity, but in keeping with the tone of Noel Carrington's introductory essay, the illustrations are straightforwardly descriptive of their subjects, without romanticizing people or places.

A pictorial documentary of village life, the book shows a cast of characters then living and working in Bardfield. Most of the people are identifiable individuals, people Bawden knew well, including his neighbours and local tradesmen and women. The rhythms and routines of rural life in this thriving but unremarkable community were at the heart of Bawden's work and life, and the surrounding gardens, farms and fields, and the churches of nearby villages, feature in his work repeatedly.

The illustrations, which were admired by contemporary reviewers,[21] were printed by autolithography, that is, Bawden himself drew directly on to the zinc plates for the outlines, and on separate plates for each colour. This was unusual; his preferred method was

to make an ink drawing, collage or linocut, which would be copied on to the lithographic stone or plate by a professional printer. He did make a number of preparatory uncoloured pen-and-ink sketches before working on the plate, and we know from the surviving sketches that the illustrations follow the sketches very closely. Despite the limitations of the process – only four colours – the illustrations have a lively immediacy.

Wallpapers

Bawden's first wallpaper was also his first linocut, a medium he was to employ in many different contexts. He had been told about the possibility of cutting and printing from lino by a friend in 1924, and he later described the genesis of his first wallpaper, *Tree and Cow* (8):

> I bought a piece of lino, the common sort universally used for covering floors, and with a tube of artist's oil paint, a brush and roll of white wallpaper, I went off home [to his lodging in Redcliffe Road] to experiment. I had on me a penknife sharp enough for cutting soft lino. There was not much room between the end of the bed and the gas fire, only enough for a chair, in the cramped space typical of a student's bed-sit of the period, and it was here on a drawing board with a piece of plain wallpaper pinned to it, that gently I put down my foot on a small cut of a cow stippled red and gave the cut gentle foot pressure. The print was better than expected so naturally the cows multiplied and were a small herd by the end of the evening.

> The next thing needed seemed to be some fields, and these were produced by cutting a frilly strip which geometrically repeated itself, leaving white paper for the fields where here and there a small herd of five cows could graze at fairly wide intervals.[22]

Bawden used these simple methods and materials for making wallpaper patterns for several years thereafter, although the designs became more ambitious, some employing as many as seven colours (*Church and Dove*), each printed from a separate block. In patterns such as *Knole Park* (11) and *Church and Dove* (9), the dense foliage patterns were influenced by the wallpaper designs of William Morris, and like Morris, Bawden valued the evidence of handcraft in the uneven printing. However, he often departed from Morris's dictum about using only flat patterns for flat surfaces, introducing elements of pictorial illusion and *trompe l'œil*, sometimes to humorous effect. These early wallpapers were printed not on rolls, but on small sheets of paper. They were produced commercially by the Curwen Press, which translated the lino blocks into lithographic plates, replicating the uneven colour of the lino prints to retain the 'handmade' character of the originals. The papers were sold through Elspeth Little's London shop Modern Textiles, set up to promote superior design and to offer something beyond the hackneyed mass-productions of established retailers. Although Oliver Simon of the Curwen Press described the designs as 'subtle, fresh and beautiful',[23] they did not sell well, and over six years Bawden's royalties were very modest. In 1933 Curwen issued five more of his linocut wallpaper patterns, which proved more popular, but again they were not commercially successful. Later, Bawden and Aldridge, working together in the attic at Brick House, printed the designs that were produced commercially, by Cole & Son in 1938–9, as the 'Bardfield' wallpapers.

Both artists were influenced by historic patterns: ivy trellises, flower sprigs and lace ribbons, as well as the architectural motifs of the Gothic Revival style of the 1830s and 40s. Production was suspended during the war, but the Bardfield papers were reissued and shown in the exhibition 'Britain Can Make It' at the V&A in 1946, where they were singled out for special praise by a reviewer who declared 'bravo, Mr Bawden.'[24] Some were exhibited again at the Festival of Britain in 1951, as representative of 'modern'

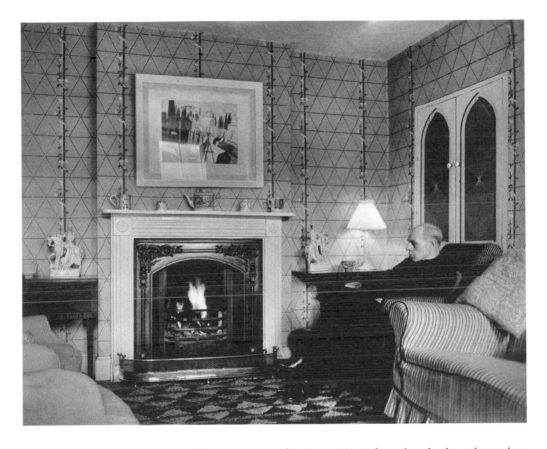

wallpapers, more adventurous in style and scale than those then being produced for the general market.[25] Bawden chose *Periwinkle* (a simple trellis with twining flowers) from this range for the sitting room at Brick House, as seen in a photograph taken in the late 1950s (**fig. 8**), but he liked his earlier designs well enough to use them when decorating the house in Saffron Walden to which he moved after Charlotte's death in 1970; there he hung *Church and Dove* in the hall and on the staircase, and the playful *Mermaid* (10) in the bathroom.

Linocut prints

If Bawden might be said to have had a favourite medium, it would probably be linocut. He first experimented with this simple method of printmaking as a student, and he subsequently employed it for wallpapers, editioned prints and designs for posters, as well as illustrations and book jackets. Linocut was briefly fashionable in the 1920s, when a group of artists known as the Grosvenor School were noted for the ambition and complexity of their colour printing in the medium, but it was not widely used after this short heyday. For Bawden, however, it proved adaptable, and unlike other print processes, where technical support was often necessary, he could control every aspect from cutting the lino to printing, using foot pressure, in his own studio. He described linocut as 'very much a designer's medium',[26] a process that made uncompromising demands on the printmaker, since a slip was irretrievable and a wrongly cut line could not be put right. Nevertheless, he became so skilful that he could cut a design in lino almost as if he were drawing, introducing an unprecedented degree of detail, and subtle gradations in texture and tone. His developing technical mastery led ultimately to the dazzling complexity and sophisticated effects achieved in his largest print, *Lindsell Church* (82) and in the magnificent *Liverpool Street Station* (81).

However, Bawden's first major linocut print was published as a lithograph. This was *Cattle Market* (39), a dense, incident-packed composition. By the time he made *Autumn* (61), which was commissioned by the V&A using funds from the Giles Bequest (established 'for the encouragement of relief-printing in colour'), he had developed a bolder, less intricate style, adding colour by overprinting and hand-stippling. Like *Autumn*, many of his prints from this period are views in Great Bardfield or the vicinity, such as *Town Hall Yard* (75), which was commended by reviewers for its skill and ingenuity, and *Ives Farm, Great Bardfield* (74), a scene of cows queuing to go into the byre for milking.

In making his later prints Bawden was influenced by his experience of designing and painting murals. He often worked on an ambitious scale with large sheets of lino, or several separate blocks, and used rich, strong colours. His dramatic and sophisticated composition *Brighton Pier* (80) makes clever use of a long, narrow format, echoing the shape of the pier itself. The contrast between the cutting and inking of the blocks for the ironwork and architecture, and that of those that represent the swelling sea, demonstrates Bawden's exceptional skill and his ability to achieve very different effects within the constraints of the lino medium. As Bliss wrote in his monograph on Bawden, 'He may well be remembered, despite all his other accomplishments, as Master of the Lino-cut.'[27]

Murals

Although there was a gap of nearly 20 years between the completion of the first Morley College mural and subsequent commissions, Bawden became something of a mural specialist. For the decoration of the dining room at the International Building Club in Park Lane, London (1937), he painted a panorama of an English landscape garden with topiary and trees framing an expanse of lawn set with tables ready for some festivity. Several motifs – a cockerel, an elegant cast-iron garden seat, a bird's nest with a clutch of eggs – would appear in his later illustrations and designs, and some features of the formal gardens in the mural were said to be inspired by Bridge End Gardens in Saffron Walden. As is so often the case with murals, this scheme was destroyed when it was painted over in the 1950s, and only a handful of photographs survive as a record.

Bawden's first significant post-war mural was for the Orient Line. Its owner, Sir Colin Anderson, was a friend of the art historian Sir Kenneth Clark, who had enlisted Bawden for the War Artists' scheme, and the commission may have come through this connection. Completed in 1946, and installed in the first-class lounge of the SS *Orcades*, this nine-panel mural entitled *English Garden*

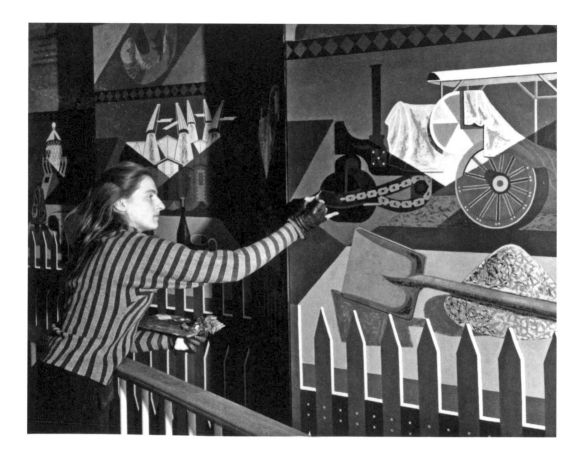

INTRODUCTION

Delights presented a series of seasonal scenes of country life on the farm and in the gardens of a variety of houses, from a *cottage ornée* to a bungalow (44). It is a celebration of a timeless rural England that Bawden returned to again and again. As a composition it is an unconventional marriage of abstraction and a flat, stylized realism, but it is nevertheless engaging and richly evocative.

The same spirit of peace and plenty characterizes Bawden's mural masterpiece, *The English Pub* (46), painted for SS *Oronsay*, sister ship to the *Orcades*. Again, the composition is a series of interconnected panels featuring an idyllic English landscape dotted with inns and public houses, with the Elephant under its neat golden thatch at the centre. To underscore the summer theme, an ice-cream seller pedals his tricycle across the bucolic scene.

Both ships served the United Kingdom, Australia, New Zealand route via the Suez Canal, and although the *Oronsay* was named after a Scottish island, and 'Orcades' is the Latin name for the Orkney Islands, the decorative schemes embodied in Bawden's murals were emphatically English. This chimed with the artist's own patriotism, rooted in his deep attachment to the traditions of English country life. His Orient Line murals were complemented by flower-patterned dinner services to his own design, as well as curtain fabrics and menus with farming motifs.

The themes of the Orient Line murals were echoed and reiterated in the mural (actually a vast concertina-like screen), now lost, that Bawden designed and painted (with help from Sheila Robinson and Walter Hoyle, both his former students and later his neighbours in Bardfield) for the Lion and Unicorn Pavilion at the Festival of Britain (fig. 9). Titled *Country Life in Britain*, it catalogued the changing seasons through a variety of rural industries, from farming and fishing to mining. Country houses, cottages and flint-knapped parish churches are the landmarks of Bawden's vision of the nation. The best surviving record of the design is his original watercolour maquette, now in the collection of the Higgins, Bedford.

Fig. 9 Sheila Robinson at work on Edward Bawden's mural *Country Life in Britain*, for the Lion and Unicorn Pavilion at the Festival of Britain, 1951 National Archives (WORK 25/206/D1/FOB-3295)

A rare instance of a mural with an urban subject is Bawden's panel for St George's Hospital, London (since relocated to Tooting, along with the mural), painted in the 1970s to show the hospital on its original site at Hyde Park Corner, in a building that is now The Lanesborough hotel. It shows the exterior of the building with Charles Sargeant Jagger's Royal Artillery War Memorial looming large to the right, and a frieze of cars and red London buses passing the front entrance (fig. 10).

Commercial illustrations

Bawden was a prolific illustrator of commercial and promotional material, press advertising and book jackets, working for a roster of clients including Shell, Twinings Tea, Fortnum & Mason, National Westminster Bank, London Transport and London & North Eastern Railway; he also designed posters for two films. His earliest commission of this kind was the brochure *Pottery Making at Poole*, which employed his calligraphic skill, his inventive delight in pattern and his love of pictorial maps (2, 3). The map of Poole was later reproduced as a tile panel for the Carter & Co. showroom, and is now in the Poole Museum. His cover and illustrations for *East Coasting*, a brochure promoting holidays to the East Coast issued by LNER, allowed free rein for his exuberant and whimsical humour, well suited to the holiday spirit (21).

Playfulness and sardonic wit are regular features of Bawden's work, and his figures are often on the cusp of caricature. We see this in the series of 35 lively line drawings for Shell, where he illustrated in appropriately cartoonish manner the punning copylines devised by John Betjeman (34, 35). These proved so popular that they were republished in a children's book, *Well on the Road* (1935, with text by Christopher Bradby), for which Bawden supplied a title page and a linocut cover design. Bawden – who never learned to drive, and relied on Charlotte – showed the car without a steering wheel.

Fig. 10 *Overleaf* St George's Hospital, Hyde Park Corner, London, 1970s
Mural, oil and paper collage on five panels
St George's Hospital, London

In the same decade Bawden supplied cover designs based on colour linocuts, and line-block illustrations for the text, for the series of food guides and cookery books compiled by the prolific food writer Ambrose Heath (the pen name of Francis Geoffrey Miller). Each printed in two colours, these cover designs are bold and simple (22, 25). Their handmade character suggests an honest, earthy hands-on practicality. In 1934, inspired by his own experience and enthusiasms, Bawden proposed the idea of a book on gardening as a companion to the *Good Food* series and enlisted his friend Cecilia Dunbar Kilburn as the author. Despite a lively correspondence in which the idea was developed, the project was never completed, but his illustrations were published in *The Gardener's Diary* (26), commissioned by Noel Carrington to commemorate the centenary of William Cobbett's *The English Gardener.*

The same lively spirit can be seen in Bawden's many illustrations for the upmarket grocer Fortnum & Mason, from a brochure advertising drinks for cocktail parties (40) to his promotions for Christmas and Easter specialities (79). For a man who was shy and often, by his own account, socially ill at ease, Bawden was nevertheless a brilliant chronicler of conviviality, as his illustrations attest, with their emphasis on hospitality, abundance and good cheer.

Bawden also designed two film posters. The first, for the Ealing Studios comedy-thriller *Hue & Cry* (1947), was not very effective, being too crowded with incident. As he later explained, he 'worked completely in the dark', with only a handful of stills to give him a sense of the storyline.[28] His second effort, for the gentle Ealing comedy *The Titfield Thunderbolt* (1953), was more successful and has become a classic of the genre, often featuring in histories of British poster design. It has a charming faux-naïf amateurishness befitting the film's storyline (68).

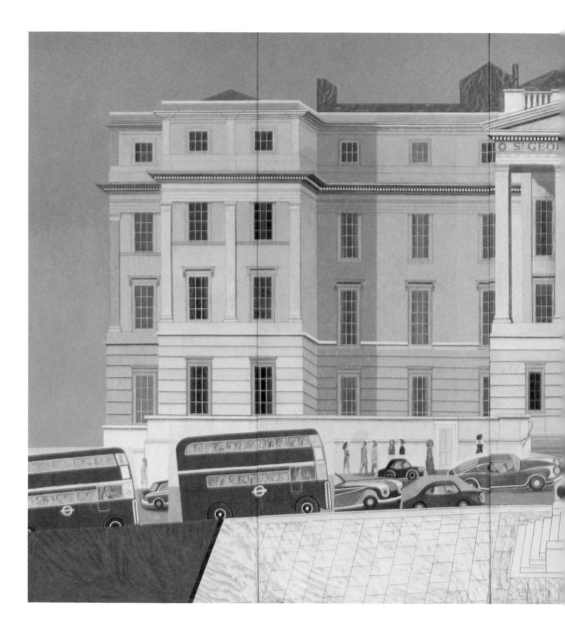

INTRODUCTION

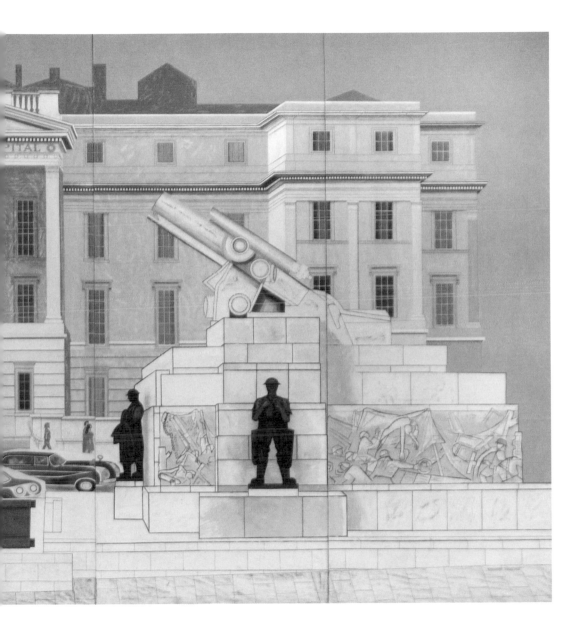

INTRODUCTION

London

Although Bawden was a committed countryman, he enjoyed London and lived there as a student and for a couple of years afterwards. While studying in South Kensington, he was a regular museum visitor, and his Natural History Museum poster conveys the wonder such collections inspired in the general public (5). He was later a regular commuter to the city, thanks to his teaching commitments at the RCA and other art schools. A keen gardener and plantsman, he had a particular interest in the London parks and the botanic gardens at Kew, and this is evident in his posters for London Underground, which focus on the flora and fauna, as well as the recreational pleasures these places offered (30–32, 42).

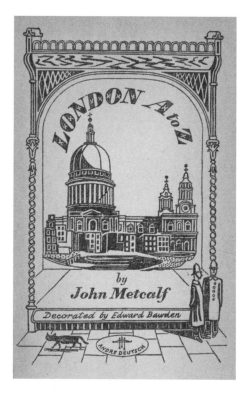

Bawden's love of Kew was such that in 1923 he designed and illustrated his own manuscript guide to the gardens (which was never published), and he supplied vivacious illustrations to Robert Herring's odd book *Adam and Evelyn at Kew, or Revolt in the Gardens* (16–19), many of which have their precedents in Bawden's earlier guide. This is in part a history of Kew Gardens, and a retelling of the story of Adam and Eve, with Kew Gardens as their Eden, produced as a limited edition with hand-coloured pochoir (stencil) prints. The Pagoda and the Palm House at Kew were two of Bawden's favourite buildings, and appeared regularly in his prints and posters.

Bawden also enjoyed London's architecture, from the City churches and St Paul's Cathedral to the elegant markets at Smithfield, Billingsgate and Leadenhall (all of which featured in his series *London Markets*, 1967), and the great iron-and-glass edifice of Liverpool Street station. His poster *City*, for London Transport, is a collage of architectural fragments celebrating the centuries of history at the heart of London (63). He illustrated David Low's miscellany of prose and verse *London Is London* (1949) with conventional

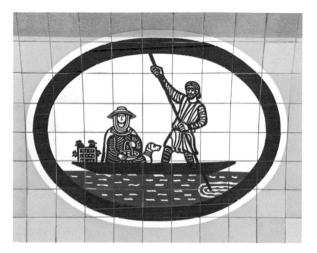

black-and-white views, and supplied some idiosyncratic vignettes to illustrate an essay on London's railway stations by John Betjeman, also published in 1949.[29] For John Metcalf's *London A–Z* (1953) he designed a bold primary-coloured cover and drew its title page, adding a typical Bawden touch, a cat slinking across the foreground (fig. 11). But for Bawden, London was also a place of ceremony and celebration. This was reflected in his ambitious gold-embellished designs for a project (never realized) to decorate the facade of the London department store Selfridges to mark the Queen's coronation. For an RCA print portfolio published on the occasion of the Coronation, he turned once more to the scene of the Life Guards on parade, their red uniforms and high-stepping horses part of a familiar scene from the spectacle of London life (67).

For the general public today, perhaps the most familiar of Bawden's works are the decorative tile panels he designed for the seat-back alcoves at three stations on the Victoria Line, which opened in stages between 1968 and 1971 (fig. 12). Each station was given a visual identity by a commissioned artist. Most opted for abstract patterns, but Bawden preferred pictorial motifs. For Victoria station he produced a simple white silhouette of the young Queen's head against a dark blue oval, like a cameo, dignified and distinctive. For the other two designs he drew on local history, and both have a medieval flavour: a turreted castle for Highbury & Islington, in reference to the 'high bury' (a manor or castle) that had once stood near the site of the station; and a passenger being ferried by a boatman across the River Lea for Tottenham Hale (the 'hale' in the place name apparently a reference to passengers 'hailing' the ferryman).

Fig. 11 Title page to John Metcalf's *London A–Z*, published by André Deutsch, 1953
Victoria and Albert Museum, London
(NAL 380418003744837)

Fig. 12 Tile panel for seat-back alcoves on London Underground's Victoria Line at Tottenham Hale and Victoria stations, London

Fig. 13 Page from Bawden's scrapbooks showing Home Sweet Home, a linocut of Hatfield House, which was his first post-war Christmas card in 1945, with a list of intended recipients. The detail of the flowering chestnut tree is from the London Transport panel poster *Chestnut Sunday; Bushy Park* (1936), reprinted as an insert in *Signature* magazine
Fry Art Gallery, Saffron Walden
(PC 1894)
Purchased with assistance from the Heritage Lottery Fund

Bawden was the subject of two television documentaries in his lifetime, one for the BBC's *Monitor* series in 1963, and another for Anglia TV in 1984.[30] In the latter he summed himself up in modest terms, as 'a pattern-maker' driven by 'a habit of work'. Although he wrote no memoir, he was a diligent archivist of his own career and his multifarious interests, and throughout his life he kept scrapbooks into which he pasted a miscellany of papers: Christmas cards (and lists of recipients), impressions of his own prints, newspaper cuttings with photographs that caught his eye, scraps of patterned paper, postcards, sketches and advertisements – a jumble of information and inspiration that reflected his own enthusiasms (fig. 13). Now in the Fry Art Gallery in Saffron Walden, these fascinating volumes have been aptly described as 'an autobiography of this most reclusive and English of artists'.[31]

INTRODUCTION

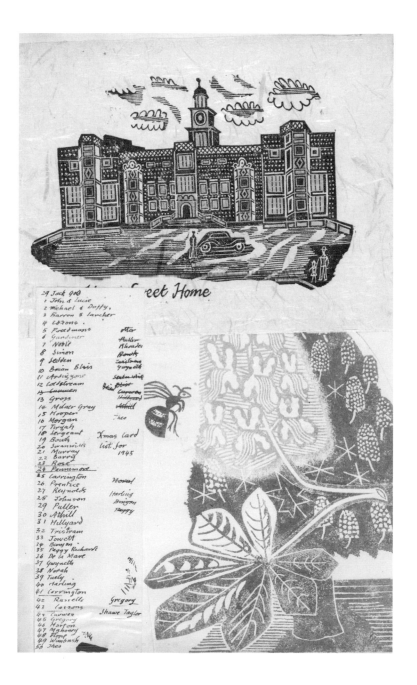

Plates

When he was still only 21, Bawden was recommended by
a tutor at the Royal College of Art to Frank Pick of London
Underground, who commissioned him to design a map
of the British Empire Exhibition, held at Wembley in 1924.
It was a challenging project, and Bawden struggled with
the cartography. As a result, Thomas Derrick, a more
experienced designer, managed the layout, creating
a structural frame for Bawden's lively vignettes of exhibits
and activities that included a football match, a fairground,
triumphs of industry and engineering, and an exuberant
firework display where dazzling pyrotechnics spell out
the words 'London Underground' against the night sky.
Around the border, a cavalcade of visitors walk, run, ride,
drive, or crowd on to buses and trains as they flock to
the site. Bawden later admitted that its scale and complexity
had defeated him, but he saw it as a valuable apprenticeship
from which he learned a great deal that he was to apply
more successfully in subsequent poster designs.

1. Map of the British Empire Exhibition,
poster and detail overleaf issued by the
Underground Electric Railways Co.
of London Ltd, 1924
Victoria and Albert Museum, London
(V&A E.277-2000)

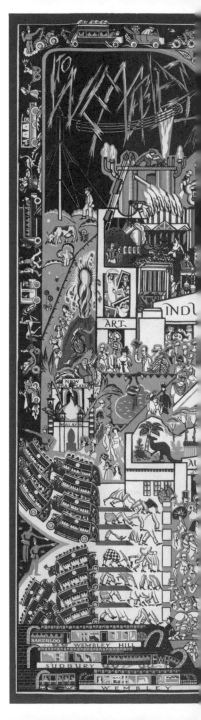

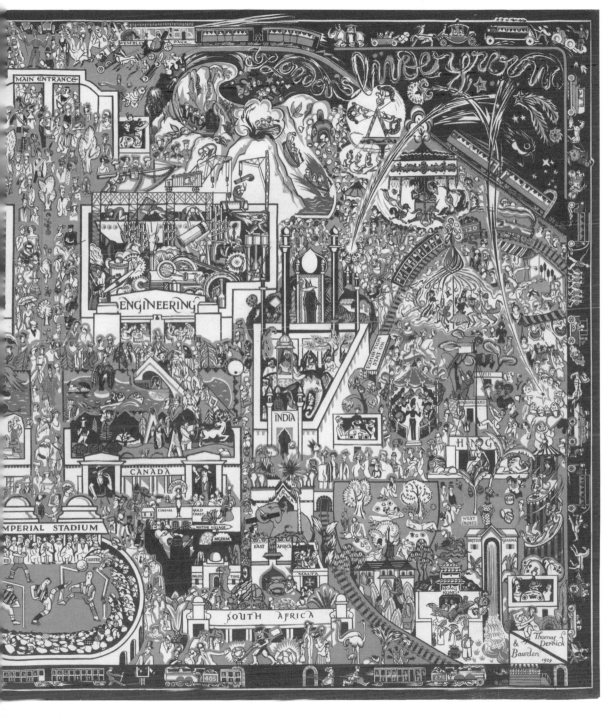

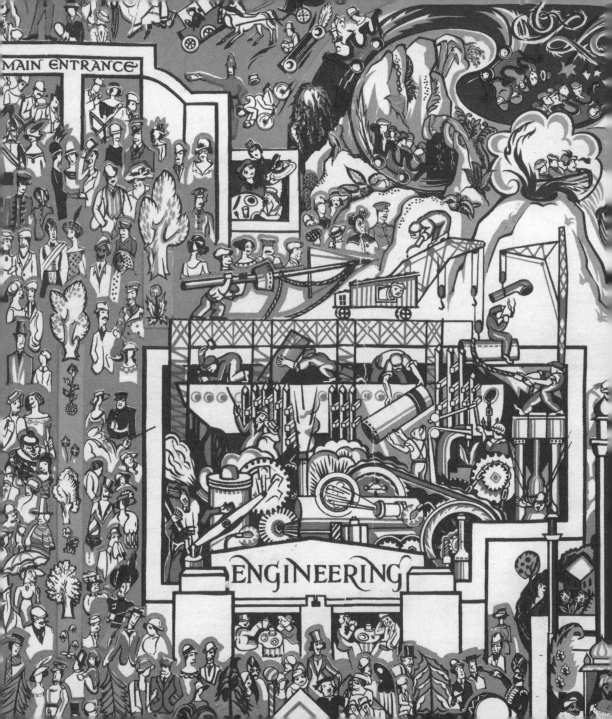

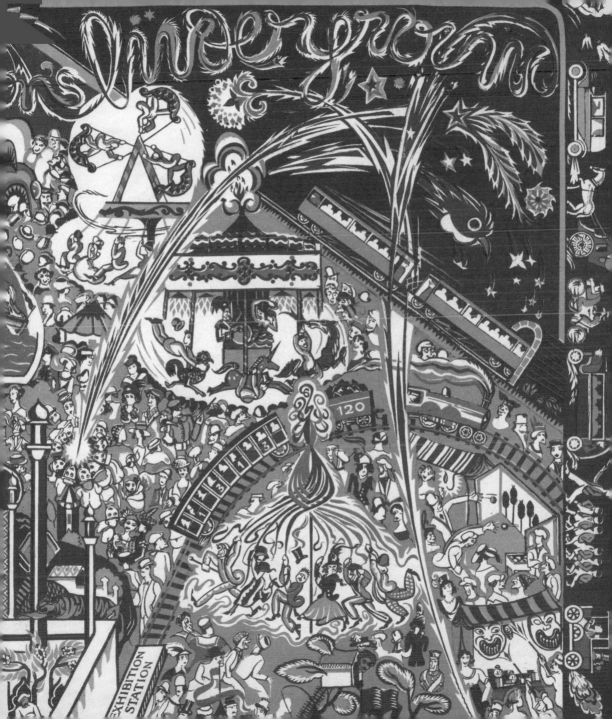

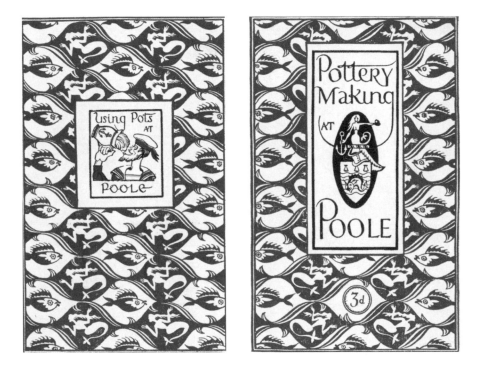

2. Back and front covers to *Pottery Making at Poole*, published by Carter, Stabler & Adams Ltd and printed at the Curwen Press, 1925
Victoria and Albert Museum, London
(NAL 38041800897753)

3. Map of Poole, illustration in *Pottery Making at Poole*, published by Carter, Stabler & Adams Ltd and printed at the Curwen Press, 1925
Victoria and Albert Museum, London
(NAL 38041800897753)

The commission to illustrate this pamphlet came through Harold Stabler, owner of the pottery-making firm Carter, Stabler & Adams. Stabler was a part-time tutor at the RCA, and it was there that he first met Bawden. Intended as a history of pottery-making in the seaside town of Poole, Dorset, where Carter & Co. had been operating since 1873, it also served as a guidebook for visitors. The cover and the pictorial map of Poole show Bawden's gift for pattern-making and his irrepressible tendency to quirky humour. This may be the earliest appearance of what was to become one of his favourite motifs, a mermaid.

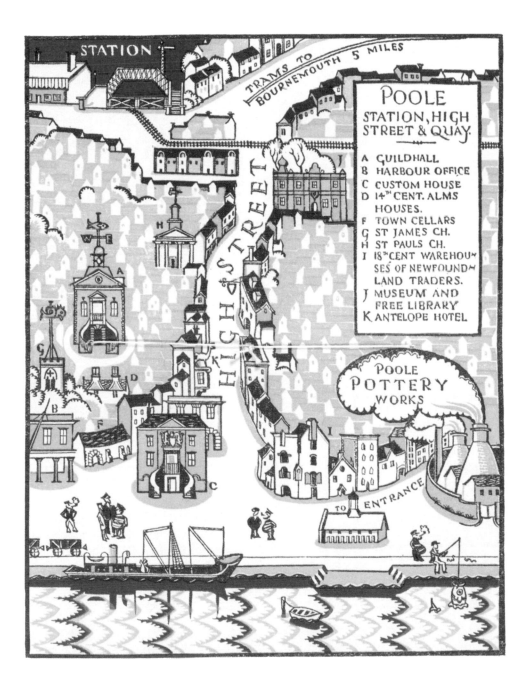

STATION

TRAMS TO BOURNEMOUTH 5 MILES

HIGH STREET

POOLE
STATION, HIGH
STREET & QUAY.

A GUILDHALL
B HARBOUR OFFICE
C CUSTOM HOUSE
D 14TH CENT. ALMS HOUSES.
F TOWN CELLARS
G ST JAMES CH.
H ST PAULS CH.
I 18TH CENT WAREHOUSES OF NEWFOUNDLAND TRADERS.
J MUSEUM AND FREE LIBRARY
K ANTELOPE HOTEL

POOLE
POTTERY
WORKS

TO ENTRANCE

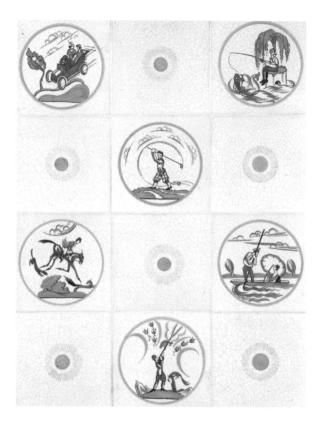

4. *Sporting*, tile panel, produced
by Carter & Co., Poole, *c.*1925–9
Hand-painted tin-glazed earthenware
Victoria and Albert Museum, London
(V&A C.11-1978)
Given by the British Institute of Industrial Art

At the request of Harold Stabler, Bawden designed a series
of tiles picturing sports and pastimes: motoring, punting,
shooting, fishing, hunting and golf. Each is deftly sketched
to give a humorous but affectionate account of the English
at play. To enhance the cheerful mood, the pictorial tiles are
interspersed with bright yellow sun motifs. The tiles were
reissued in 1955.

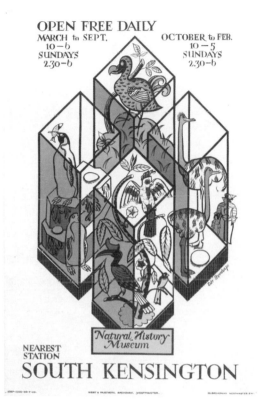

5. *Natural History Museum*, poster issued
by Underground Electric Railways Co.
of London Ltd, 1925
Colour lithograph
Victoria and Albert Museum, London
(V&A E.1516-1925)

To summarize the exhibits at the Natural History Museum, this
poster presents an isometric view of four adjacent display cases
in the ornithological galleries where the specimens include
penguins, a dodo, ostriches with an egg, and a cockatoo sharing
a branch with a hornbill. There is a whimsical character
to the birds, despite the ostensibly 'scientific' presentation.
The woman and child, just glimpsed beside the ostriches,
appear tiny by comparison, as if to emphasize how impressive
and awe-inspiring the displays would appear to visitors.

Another of Bawden's earliest poster commissions for London Underground, this has a picture-book symmetry that reflects the formality of the Whitehall architecture and the serried ranks of the mounted Queen's Life Guards. The Changing of the Guard was a popular spectacle at the time and continues to be a tourist attraction.

6. *Changing the Guard*, poster issued by the Underground Electric Railways Co. of London Ltd, 1925
Colour lithograph
Victoria and Albert Museum, London
(V&A E.1169-1925)
Given by the Underground Electric Railways Co. of London Ltd

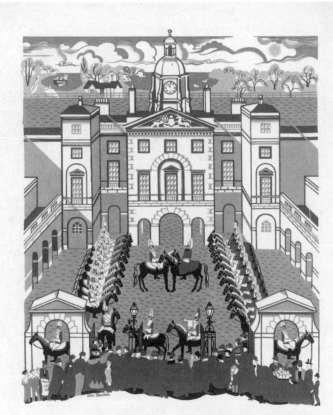

AT THE HORSEGUARDS WHITEHALL
at 11a.m (Sundays at 10 a.m.)
Nearest Stations:–
Westminster and Trafalgar Square.

AT BUCKINGHAM PALACE or ST JAMES'S PALACE
between 10·30 and 11·15 a.m.
Nearest Stations:–
St James's Park and Dover Street.

CHANGING THE GUARD
LONDON'S DAILY MILITARY TATTOOS

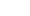

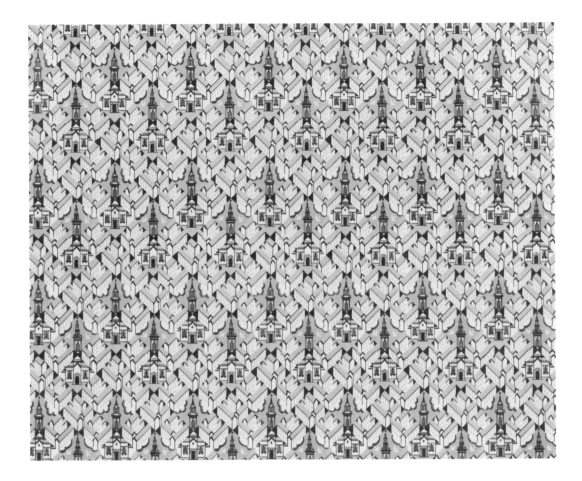

7. Cover paper for a book on
London (detail), 1927
Colour lithograph
Victoria and Albert Museum, London
(V&A E.3873-1934)

The intended application of this pattern was as the cover or
endpapers for a book on London, but it was perhaps never
used. It is a dense and complex design, using two perspectives.
A frontal elevation of a church is shown with its spire silhouetted
against a blue sky edged with curly clouds, while the surrounding
buildings are shown in isometric view from above.

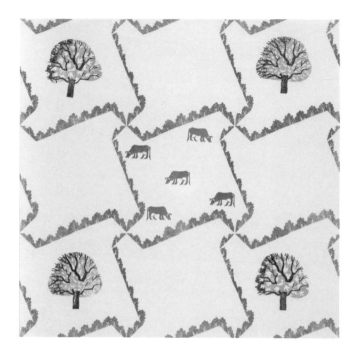

8. *Tree and Cow*, wallpaper, printed and published by the Curwen Press, 1927
Colour lithograph after linocut original
The Higgins, Bedford
(B.32a)

This design for wallpaper was the result of Bawden's early experiments with linocutting when he was a student. It and several other of his linocut wallpaper patterns were reproduced as lithographs by the Curwen Press, and sold through Elspeth Little's shop Modern Textiles in Knightsbridge, but despite their cheerful charm they had little commercial success.

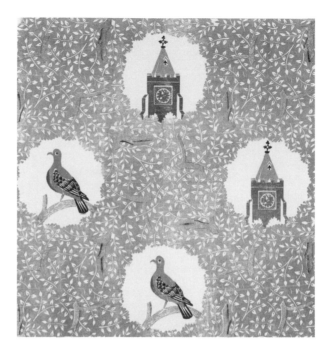

9. *Church and Dove*, wallpaper, printed
and published by the Curwen Press, 1927
Colour lithograph after linocut original
Victoria and Albert Museum, London
(V&A E.1398-1979)
Given by Modern Textiles

Also known as *Woodpigeon*, this is one of a group of designs
by Bawden marketed as *The Plaistow Wallpapers* (after the
area of east London where the Curwen Press was based).
In common with the later *Knole Park* (11), it has an all-over
foliage pattern like a neatly trimmed hedge, here punctuated
by 'windows' through which a church tower and a pigeon can
be seen. In 1932 the *Architectural Review* applauded Bawden's
wallpaper designs but lamented the lack of enthusiasm on the
part of mainstream manufacturers that resulted in the papers
being printed in a 'semi-private way' and finding few buyers.
Bawden used many unsold pieces of his own wallpapers at
Brick House, and later in his home in Saffron Walden, where
this pattern featured in the hallway.

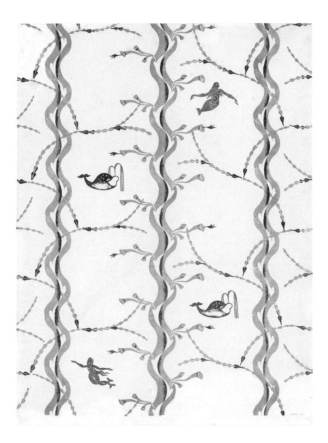

10. *Mermaid,* wallpaper, printed and
published by the Curwen Press, 1928
Colour lithograph after linocut original
Victoria and Albert Museum, London
(V&A E.543-1931)

In one of Bawden's more whimsical designs, a trellis of
sinuous seaweed frames spouting whales and frolicking
mermaids. Mermaids frequently pop up in Bawden's
designs and illustrations, as do pigeons and cats.

11. *Knole Park*, wallpaper, printed and published by the Curwen Press, 1929
Colour lithograph after linocut original
Victoria and Albert Museum, London
(V&A E.960-1978)

Bawden's wallpaper designs were initially inspired by William Morris's *Daisy* pattern, which he had seen in 1924 at the British Empire Exhibition at Wembley. The influence of Morris is apparent here in the diagonal foliage motif, although the pattern as a whole has none of the sophistication and complexity that characterized many of Morris's wallpapers. Bawden's visual wit is at play here; the pictorial scenes sit on the patterned ground as though they are pictures on a papered wall.

12. *Napkin and Fruit*, wallpaper, printed
and published by the Curwen Press, 1928
Colour lithograph after linocut original
Victoria and Albert Museum, London
(V&A TN.241-2019)

This bright pictorial design with a simple half-drop repeat was
perhaps intended for a kitchen or dining room. The rendering
of the folds and drapes of the napkins creates a *trompe l'œil*
effect of three-dimensional decoration.

13. *Conservatory*, wallpaper, printed and
published by the Curwen Press, 1929
Autolithograph
Victoria and Albert Museum, London
(V&A E.544-1981)

For the most part, Bawden produced his wallpapers as small
linocut sheets, and the blocks were then used to transfer the
designs to lithographic plates so that they could be printed
in greater quantities. However, this is a rare instance of Bawden
himself drawing the design directly on to the lithographic
plate. There is a characteristic gently humorous cast to
the design, in which ladies and gentlemen in Victorian dress
parade through conservatories filled with vases of flowers
as big as the figures themselves.

Bawden made several small engravings between 1927 and 1929, in a simple linear style that is very different from the boldly coloured linocuts for which he was later famous. In creating this lyrical scene, he may have been inspired by the nineteenth-century British landscape painter Samuel Palmer (fig. 6), a Romantic visionary who was an important influence on several artists of Bawden's generation, thanks to a major exhibition of his work at the V&A in 1926.

14. *Lane in Moonlight*, 1928;
printed about 1973
Engraving
Victoria and Albert Museum, London
(V&A E.3175-2004)
Purchased through the Julie and Robert
Breckman Print Fund

Lane in

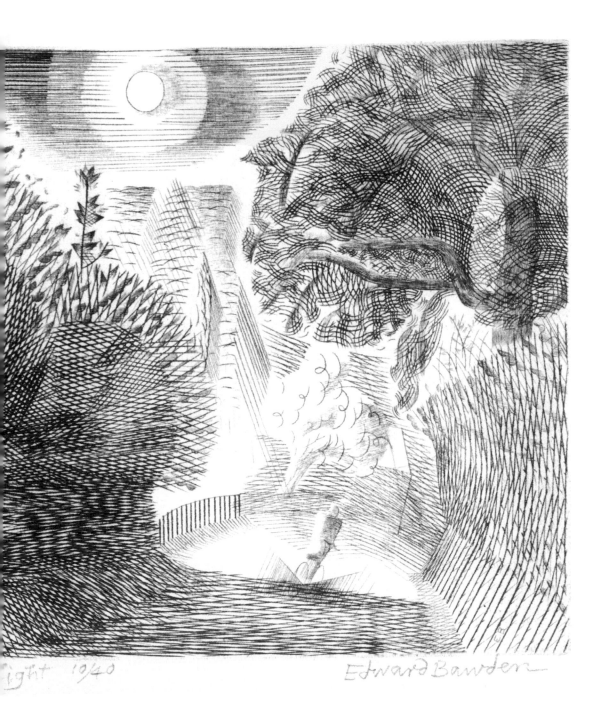

Edward Bawden

This was one of a series, the *Ariel Poems*, published by Faber & Gwyer between 1927 and 1931. Each four-page pamphlet paired a Faber author with a contemporary artist. The avant-garde and somewhat eccentric writer Edith Sitwell was perhaps an unlikely partner for Bawden, but his illustrations, with their vivacious, exuberant charm, capture the spirit of the poem's protagonist, 'Lily O'Grady, Silly and shady', whose 'gown with tucks/ Was of satin the colour of shining green ducks'.

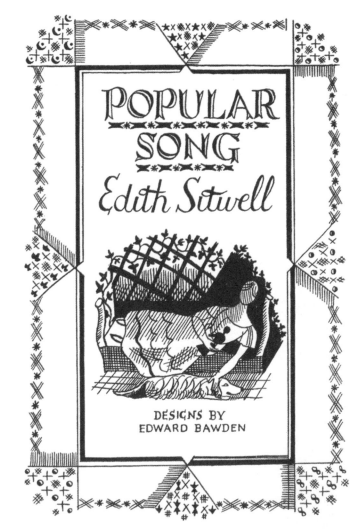

15. Title page and frontispiece to *Popular Song*, from *Façade* by Edith Sitwell, published as *Ariel Poem No. 15* by Faber & Gwyer, 1928
Victoria and Albert Museum, London
(NAL 38041800559049)

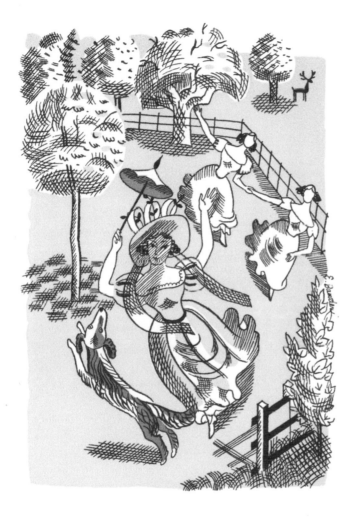

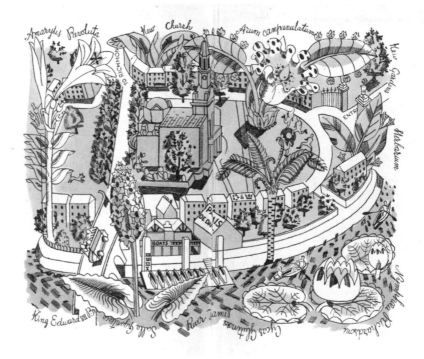

16. Illustration to Robert Herring,
*Adam and Evelyn at Kew, or Revolt
in the Gardens,* published by Elkin
Mathews & Marrot, London, 1930
Pochoir print, coloured by hand
Victoria and Albert Museum, London
(NAL.2233-1950)

Bawden was commissioned to provide the artwork for
Herring's story set in Kew Gardens. This was a project
that he seems to have enjoyed, given his love of the place.
As endpapers, he provided a map of the gardens themselves
at the front and of Kew Green at the back. Here we see
the church on the green adjacent to the main entrance
to the grounds, but everything is out of scale, notably the
giant lily pads floating in the river. Despite the constraints
of the format, which required Bawden to compress or skew
the perspective, many of the buildings featured here were
accurately observed and can still be identified today.

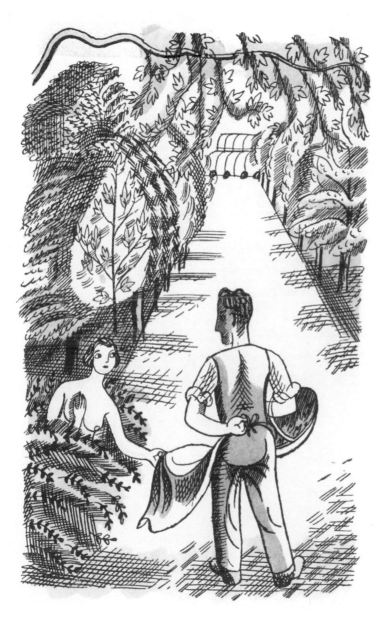

'There she was, standing by him. Fresh from the pond, and without tresses to comb conveniently.' In Herring's story, Evelyn is an actress playing the part of Fanny Burney in a film about the life of King George III. In an attempt to escape an encounter with the king, she falls into the pond, and retreats to the shrubbery to shed her wet clothes. Seeing Adam the gardener approaching, she asks to borrow his apron to wear until she can retrieve her clothes. Thanks to her fashionably bobbed hair, she has no long tresses to cover her nakedness.

17. Illustration to Robert Herring, *Adam and Evelyn at Kew, or Revolt in the Gardens*, London, 1930 Pochoir print, coloured by hand Victoria and Albert Museum, London (NAL L.2233-1950)

'Evelyn liked the great
leaves and the tendrils.
The steamy heat pleased
her; but it reminded Adam
of somewhere he had been
before, he couldn't remember.'
In this scene, inside the
Palm House, we see visitors
climbing the wrought-iron
spiral staircase that gave
a closer view of the leafy
canopy. Bawden gave free
rein to his imagination here;
the figures are puny beside
the vast leaves of palms, the
vines and succulents, and
the rapacious trumpets
of the fantastical flowers.

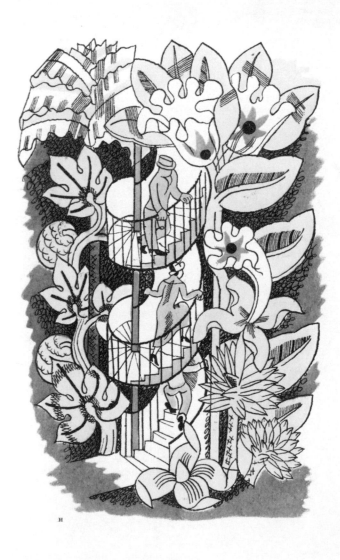

18. Illustration to Robert Herring,
*Adam and Evelyn at Kew, or Revolt
in the Gardens*, London, 1930
Pochoir print, coloured by hand
Victoria and Albert Museum, London
(NAL L.2233-1950)

'Most of the people were chattering fools, who spent their time eating the buns they had brought and sat, back to the views, with their noses buried in bags and baskets.' Herring's contempt for the garden's visitors is reflected in Bawden's illustration in which a couple turn their backs on the Pagoda and eat their picnic, scattering crumbs to the birds and littering the path with banana skins and discarded newspapers, carelessly despoiling their Edenic surroundings. This is one of several illustrations that had a direct precedent in Bawden's manuscript guide to Kew from 1923.

19. Illustration to Robert Herring,
*Adam and Evelyn at Kew, or Revolt
in the Gardens*, London, 1930
Pochoir print, coloured by hand
Victoria and Albert Museum, London
(NAL I.9233 1950)

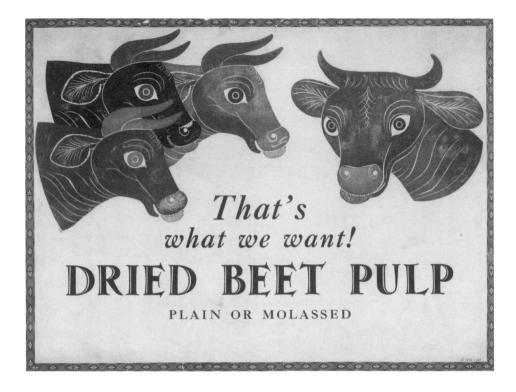

20. 'That's what we want! Dried Beet Pulp
Plain or Molassed', poster published by
the Empire Marketing Board, 1930
Colour lithograph
Victoria and Albert Museum, London
(V&A E.1672-1931)
Given by Harold Curwen

This poster, with its simple, bold design, shows four bullocks
licking their lips in anticipation of the tasty dried beet pulp.
Their eyes are drawn like bullseyes on an archery target,
a typical instance of Bawden's sly visual punning. Beet pulp
is a by-product of the sugar-beet industry and has long been
used as food for horses and cattle.

The title page of this brochure, published to promote holidays on the east coast of England, is a comic confection of playful anecdotes, garlanded by shells and seaweeds. In one, a woman is seized from her invalid carriage by a giant lobster, while her male companion is startled by an amorous mermaid. Bawden's friend Eric Ravilious found the composition so delightful that he had a copy framed to enjoy whenever he was feeling low.

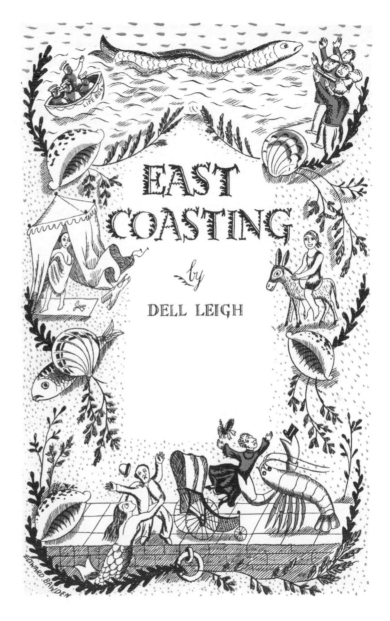

21. Title page to *East Coasting* by Dell Leigh, issued by the London & North Eastern Railway, 1931
Offset lithograph
Victoria and Albert Museum, London
(NAL. 38041800010431)

This was the first title
in what became a popular
series by the journalist and
food writer Ambrose Heath.
Bawden was given a free
hand in the design of the
illustrations and each
monthly scene, based on his
own observations, is a lively
complement to Heath's text.
This book focused on recipes
for food by season and the
cover design reflects this,
with a playful frame comprised
of cutlery supporting an
abundance of fresh foodstuffs:
eggs, chicken, fish, apples and
pears, raspberries, figs and
cherries, as well as drooping
ears of corn.

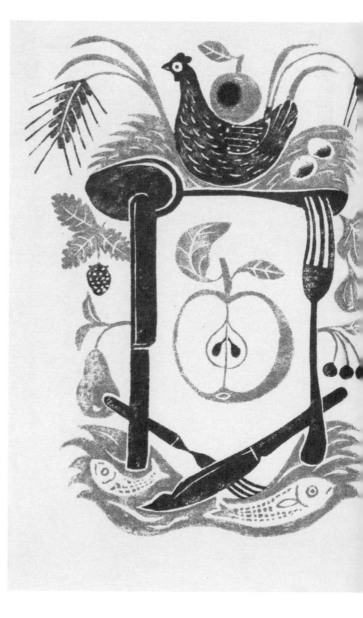

22. Dust jacket for Ambrose Heath's
Good Food, Faber & Faber, 1932
Lithography after linocut originals
Victoria and Albert Museum, London
(V&A AAD/1995/8)

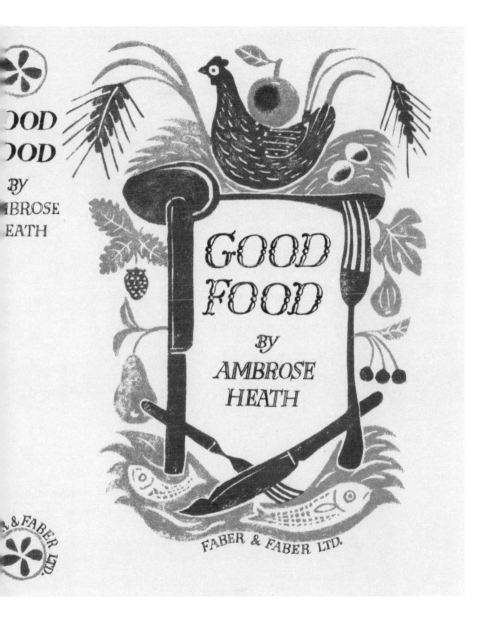

GOOD
FOOD

BY
AMBROSE
HEATH

FABER & FABER LTD.

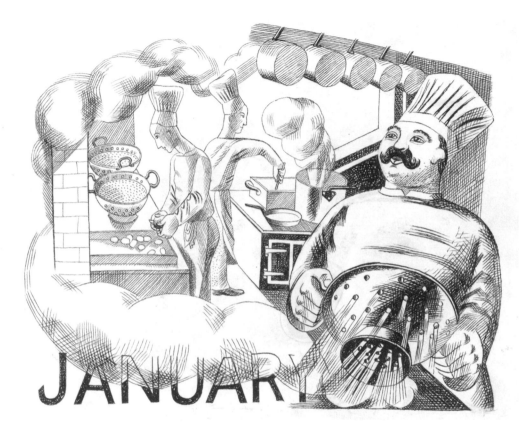

JANUARY

23. 'January', original drawing for
illustration to Ambrose Heath's *Good
Food* (Faber & Faber, 1932), *c.*1932
Pen and ink
Victoria and Albert Museum, London
(V&A E.426-1982)

As Bawden later recalled, this and the headpiece for 'November'
in Heath's book of seasonal recipes show scenes in the steamy
kitchens of a restaurant on London's Tottenham Court Road,
at the corner with New Oxford Street. This is the working
sketch for the printed illustration; a correction to the drawing
of the right hand of the moustachioed chef has been cut from
another sheet and pasted on.

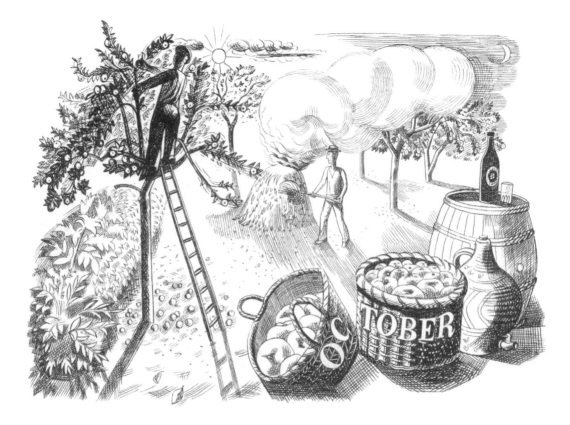

24. 'October', original drawing for
illustration to Ambrose Heath's
Good Food (Faber & Faber, 1939), *c.*1932
Pen and ink
Victoria and Albert Museum, London
(V&A E.427-1982)

The illustration introducing 'October' is a celebration of the
apple harvest, with picking in progress, windfalls scattered
on the grass, and great wicker baskets already brimful of fruit.
Hinting at the various uses of apples beyond the culinary,
Bawden has also included a flagon of cider and what may
be a cask of apple brandy. The autumnal mood of the scene
is enhanced by the long shadows cast by the low afternoon sun,
and the billowing smoke from the bonfire.

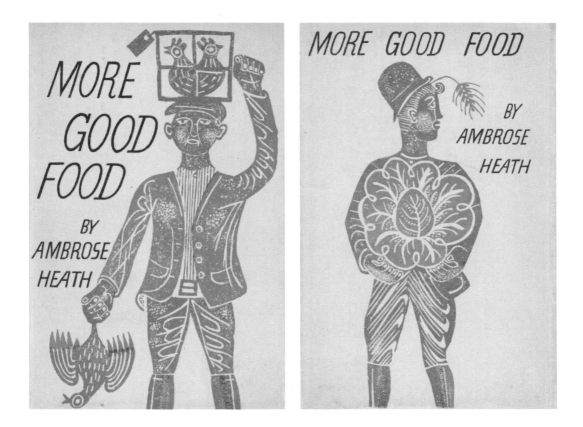

25. Front and back covers
to Ambrose Heath's *More Good
Food*, Faber & Faber, 1933
Lithography after linocut originals
Victoria and Albert Museum, London
(NAL 38041989072707)

26. Cover to *The Gardener's Diary*,
Country Life Books, 1937
Fry Art Gallery, Saffron Walden

The dust jacket for this title in Heath's series of cookery books
shows two sturdy countrymen taking their produce to market.
As so often with Bawden's book illustrations, there is an
element of affectionate caricature in these bold linocuts.
On the front cover a flat-capped farmer carries a cage of
chickens on his head, with another trussed fowl hanging
from his hand. On the back a young man with an ear of corn
dangling from his hatband holds a magnificent cabbage that
appears to flower from his torso.

After he and Charlotte had settled at Brick House, Bawden became a keen gardener. This was a passion he shared with his Great Bardfield neighbour and fellow artist John Aldridge, and other friends including Cecilia Dunbar Kilburn, who had been a student with Bawden at the Royal College of Art. In the mid-1930s he and Dunbar Kilburn planned to collaborate on a gardening book. This was never realized, but Bawden was later commissioned by Noel Carrington of Country Life Books to design and illustrate a gardener's diary. He produced 52 illustrations, some of which originated from the earlier project; these appeared as headers to the double-page spreads for each week. The cover illustration comprises scattered leaves and flowers, and a robin (a frequent companion, as all gardeners know) perched on an old boot. Bawden added his initials as if carved on a piece of fallen bark.

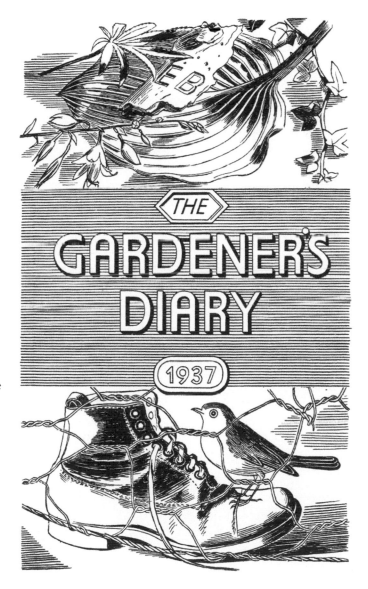

Bawden's watercolour style in the 1930s was characterized
by an emphasis on texture, pattern and shadow, all of which
are apparent in this view of the church in Little Sampford,
a village not far from Great Bardfield. Also demonstrated
here is his typical watercolour technique, which involved
applying pigment with what he called a 'starved' or dry
brush. This allowed him greater control over the painting
than would have been possible if he had used wetter pigment.
Reviewing a retrospective of Bawden's work at the V&A in
1989, John Russell Taylor praised his watercolours as works
of 'sophisticated naivety'.

27. *Christ! I have been many*
times to church, 1933
Watercolour
Victoria and Albert Museum, London
(V&A P.15-1964)
Given by Miss Louisa Puller

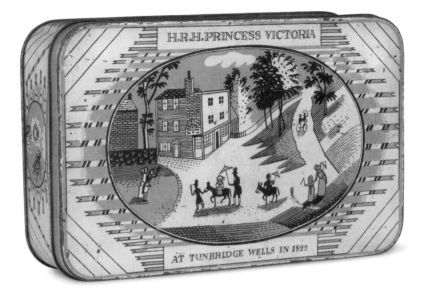

28. Biscuit tin, designed for
A. Romary & Co. Ltd, *c.*1933–4
Offset lithograph printed on tinplate
Victoria and Albert Museum, London
(V&A M.746-1983)
Given by M.J. Franklin

Biscuit tins with decorative designs were introduced as a result of new legislation in the 1860s, which allowed groceries to be individually packaged for sale. The new process of offset lithography, patented in 1877, made it possible to print coloured designs directly on to tinplate, and the novelty biscuit tin became a popular product, especially for the gift market. Bawden's design, produced for Christmas 1933, is based on an early nineteenth-century print that shows a young Princess Victoria riding her donkey in Tunbridge Wells, a town she visited often in the 1820s and 30s. Alfred Romary's business, which specialized in wafer biscuits, was established in the town in 1862. As queen, Victoria visited the shop in 1876 and granted the business a royal warrant; Bawden's tin celebrates this historic royal association.

29. Pattern paper, designed for London Transport, 1935, originally published by the Curwen Press, published by Judd Street Gallery, 1988
Colour lithograph after a wood engraving
Victoria and Albert Museum, London
(V&A E.190-1998)

Seen at a distance, this appears to be an abstract pattern, but up close one can see that the design incorporates two seated bowler-hatted figures representing commuters on a train or tram. It was designed as the cover for a London Transport appointments diary, but was never used.

Pelicans have had a home in Regent's Park since 1664, when the first birds arrived as a gift from the Russian ambassador. Bawden put a pelican at the centre of his poster promoting the park, alongside a homely London pigeon and some bright dahlias, a notable feature of the floral displays in the gardens. All are overlooked by the massive sculpture of Achilles installed in 1822 as a tribute to the first Duke of Wellington. The background to these disparate figures was created from a collage of torn paper, typical of Bawden's poster style of this period.

30. *Regent's Park*, poster issued by London Passenger Transport Board, 1936
Colour lithograph
Victoria and Albert Museum, London
(V&A E.1071-1936)
Given by London Passenger Transport Board

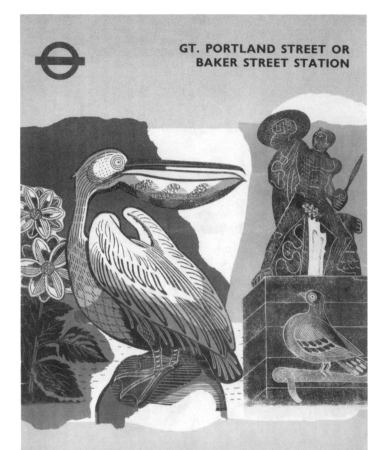

GT. PORTLAND STREET OR
BAKER STREET STATION

SEE THE SHOWS OF DAHLIAS
NEAR CLARENCE GATE & ST. ANDREW'S GATE

REGENT'S PARK

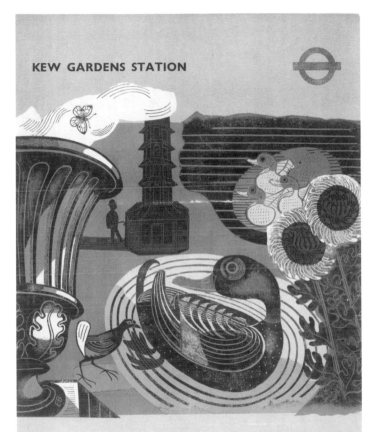

KEW GARDENS STATION

OPEN DAILY, ADMISSION 1ᴰ
TUESDAYS & FRIDAYS (STUDENTS DAYS) 6ᴰ

KEW GARDENS

Using a favourite compositional strategy, Bawden here unites a number of vignettes in the manner of a collage to highlight the various attractions to be found at Kew. The Pagoda, which features in several of his prints and posters, is the eye-catching focal point here, its bright red echoed in the sunflowers and the duck's feet.

31. *Kew Gardens*, poster issued by the London Passenger Transport Board, 1936
Colour lithograph
Victoria and Albert Museum, London
(V&A E.1070-1936)
Given by London Passenger Transport Board

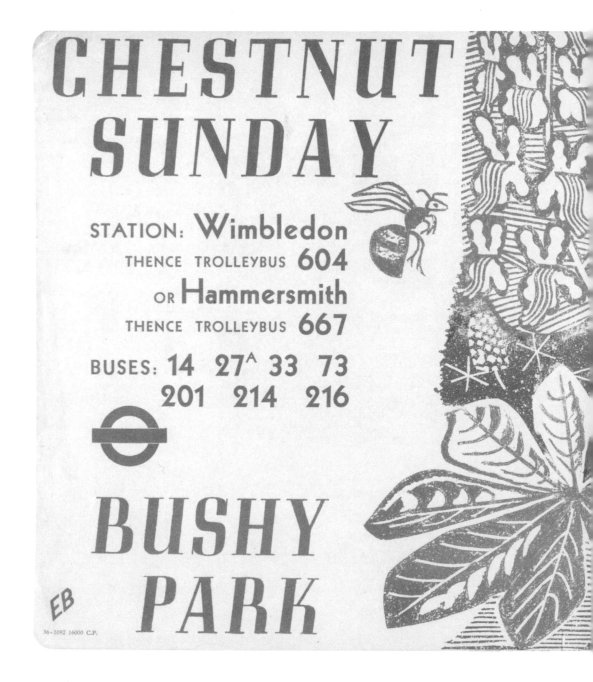

CHESTNUT
SUNDAY

STATION: **Wimbledon**

THENCE TROLLEYBUS **604**

OR **Hammersmith**

THENCE TROLLEYBUS **667**

BUSES: **14 27^A 33 73**
201 214 216

BUSHY
PARK

EB

36-1092 16000 C.P.

Bushy Park at Hampton Court, once Henry VIII's hunting ground, is home to a mile-long avenue of horse chestnut trees designed by the architect Sir Christopher Wren. This small poster for London Transport was one of several designed to encourage Londoners to celebrate 'Chestnut Sunday', an annual event held in the park in May, when the trees' flowers are at their best. In a typically humorous detail, Bawden's design includes a cheerful bee hovering beside the blossom. The uneven printing of the original three-colour linocut was reproduced in the lithographic poster, giving it a pleasingly handmade look.

32. *Chestnut Sunday: Bushy Park*, poster for London Transport Passenger Board, 1936
Lithograph after linocut original
Victoria and Albert Museum, London
(V&A C.12485)

The 1920s and 30s brought an extraordinary expansion in private car ownership. Shell, a retailer of motor oil and petrol products, promoted touring by car in a series of now iconic posters commissioned from leading artists of the time. Designed to appeal to the discerning middle-class customer, the advertising campaign eschewed well-known beauty spots and popular tourist attractions in favour of less familiar landscapes and historic buildings, such as the seventeenth-century Walton Castle in Somerset. Bawden's poster offers a straightforward topographic view of the ruin that emphasizes its bleak remoteness.

33. *Walton Castle, Clevedon, Somerset.*
To Visit Britain's Landmarks You Can
Be Sure of Shell, 1936
Colour lithograph poster
Beaulieu Motor Museum, Hampshire
(Cat. No.474)

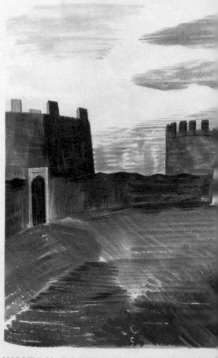

TO VISIT

WALTON CASTLE, CLEVEDON, SOME

YOU CAN

EDWARD BAWDEN.

BE SURE OF SHELL

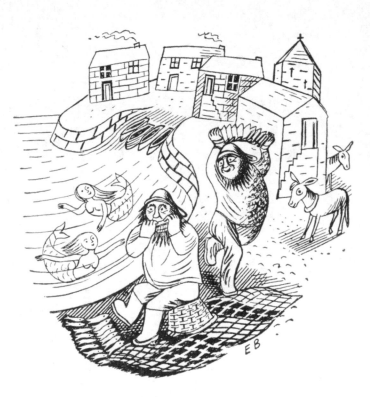

34. *Lanteglos by-Fowey but Motorists Buy Shell*, advertisement issued by Shell-Mex and BP Ltd, *c.*1934
Letterpress and line block
Victoria and Albert Museum, London
(V&A C.11357A)
Given by Messrs Shell-Mex and BP Ltd

Bawden designed a series of press advertisements for Shell petroleum in the 1930s. Comic scenes of stereotypical life in various British towns and villages are headlined with verbal puns that play on place names, most of them composed by John Betjeman, the copywriter for this campaign. To characterize Lanteglos-by-Fowey, on the coast of Cornwall, Bawden presents two jolly fishermen on the harbour wall serenading a couple of mermaids with music from a harmonica and a concertina.

STOKE-ON-TRENT

BUT

SHELL ON THE ROAD

YOU CAN BE SURE OF SHELL

35. Stoke-on-Trent but Shell on the Road,
advertisement issued by Shell-Mex
and BP Ltd, 1930s
Letterpress and line block
Victoria and Albert Museum, London
(V&A C.11354A)
Given by Messrs Shell-Mex and BP Ltd

In another of Bawden's press advertisements for Shell, the scene shows ranks of bottle kilns, then very prominent in Stoke, at the heart of the Staffordshire potteries. The 1930s brought a growing enthusiasm for leisure travel by car, and Shell ran a number of campaigns promoting England's most picturesque towns and villages, employing artists to provide eye-catching imagery.

Framed by a pattern of oak leaves and branches are views of three country houses: Eastbury Manor House in Barking, Essex (an Elizabethan property then housing the Barking Museum), Knebworth in Hertfordshire (home of the writer and politician Edward Bulwer-Lytton) and Knole in Kent (home of the Sackville family), all within easy reach of London for a day trip by public transport. The patterned ground is reminiscent of Bawden's Morris-inspired wallpapers. The vignettes of the houses, reproduced from linocut originals, have a simple picture-book charm.

36. *Barking/Knebworth/Knole*, poster issued by the London Passenger Transport Board, 1936
Colour lithograph and letterpress
Victoria and Albert Museum, London
(V&A E.118-1976)

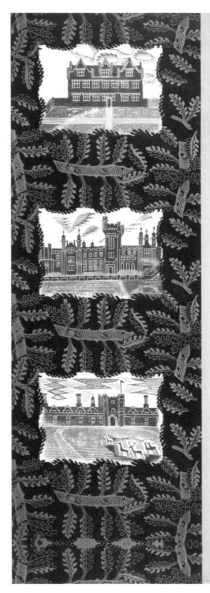

BARKING

EASTBURY MANOR HOUSE (Elizabethan) now the Barking Corporation Museum. Tuesdays 11 to 5; Wednesdays 11 to 5; Thursdays 11 to 9; Fridays 11 to 6; Saturdays 11 to 6; Sundays 2 to 6.

1/3 return ($^{Coach}_{fare}$) Coach Z1 or Z2 from Aldgate (Minories) or Underground to Upney Station.

KNEBWORTH

KNEBWORTH HOUSE, the home of Bulwer-Lytton. By permission of the Earl of Lytton, house and gardens open weekdays 11 to 6; from 1st October 11 to 4. House closed 1 to 2. Admission 1/- (Fridays 2/6).

3/6 return Coach K1 or K2 from Marble Arch (Park Lane)

KNOLE

KNOLE HOUSE, the home of Lord Sackville. The show rooms contain furniture, pictures and tapestries. Thursdays 2 to 5; Saturdays 2 to 5; Fridays 10 to 1 & 2 to 5. Admission 2/- (Fridays 4/-). The Park open free, daily.

3/- return Coach C1, C2 or D from Victoria (Eccleston Bridge)

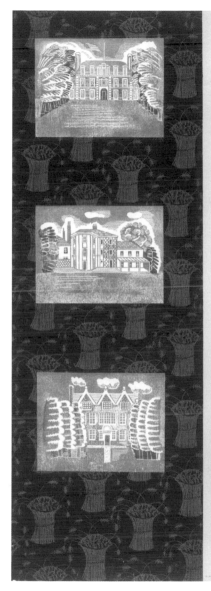

TRING PARK, the home of
Lord Rothschild. Zoological
Museum on view. Mondays to
Wednesdays 3 to 6; Fridays
10 to 12 and 3 to 6. From 1st Oct.
Mondays to Wednesdays 1 to 4;
Fridays 10 to 12 and 2 to 4.

3'6 return Coach E
from Marble Arch (Park Lane)

DOWN HOUSE, Charles Darwin
lived here. The old study in
which the "Origin of Species"
was written and other rooms
on view. Daily 10 to 6; from
1st October 11 to 4.

2/- return ($^{Coach}_{fare}$) Coach D
from Victoria (Eccleston Bridge)
to Keston Church, thence bus 146^

QUEBEC HOUSE, early home
of General Wolfe. Pictures and
personal belongings on view.
Open from mid-October,
Tuesdays, Thursdays and
Saturdays 10 to 1 and 2 to 5.

2'9 return Coach D
from Victoria (Eccleston Bridge)

This poster follows the
same design formula as
its companion for Barking,
Knebworth and Knole (36),
here with a repeat pattern
of wheat sheaves framing
views of Tring Park in
Hertfordshire (home to
Lord Rothschild's zoological
collections), Down House
in Downe, Kent (the former
home of Charles Darwin),
and Quebec House in
Westerham, Kent (the early
home of General Wolfe).
The poster promotes all three
as destinations for outings
by coach from London.

37. *Tring/Downe/Westerham*, poster
issued by the London Passenger
Transport Board, 1936
Colour lithograph and letterpress
Victoria and Albert Museum, London
(V&A E.119-1976)

On visits to the Sussex port of Newhaven with Eric Ravilious, Bawden made several watercolours, all painted on the spot. As the titles – which give just the month and the time of day – would suggest, these pictures are first and foremost studies of changing light and weather, the other features being almost incidental. The apparent simplicity of this scene, a small rowing boat on a slipway, is enlivened by Bawden's evident pleasure in colour and texture: the rough reddish-brown boards of a boat shed and the subtly different shade of its door; the worn grey paint on the boat; and the regular lines of the slipway contrasted with the cobbled paving beside it, described simply by a series of interlocking wavy lines of greyish pigment. Paul Nash, praising Bawden's watercolour technique, described his manner in the Newhaven pictures as 'a kind of watercolour "pointillism" in the style of Seurat'.[33]

38. *September: Noon*, 1937
Watercolour
Victoria and Albert Museum, London
(V&A Circ.67-1938)

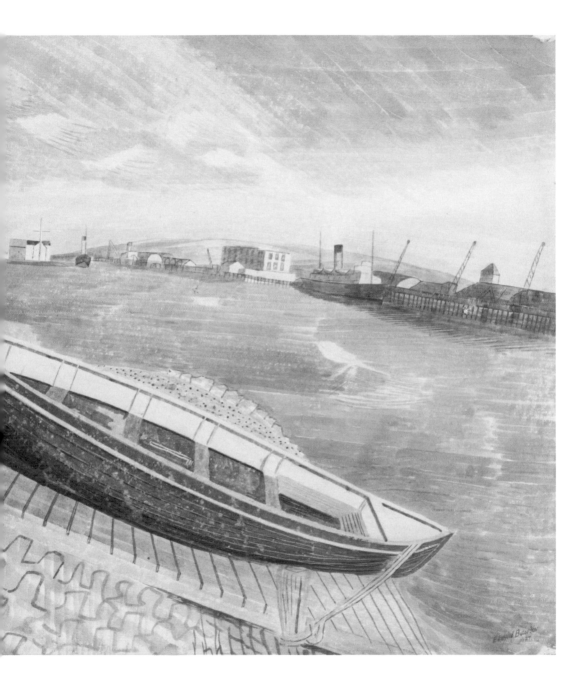

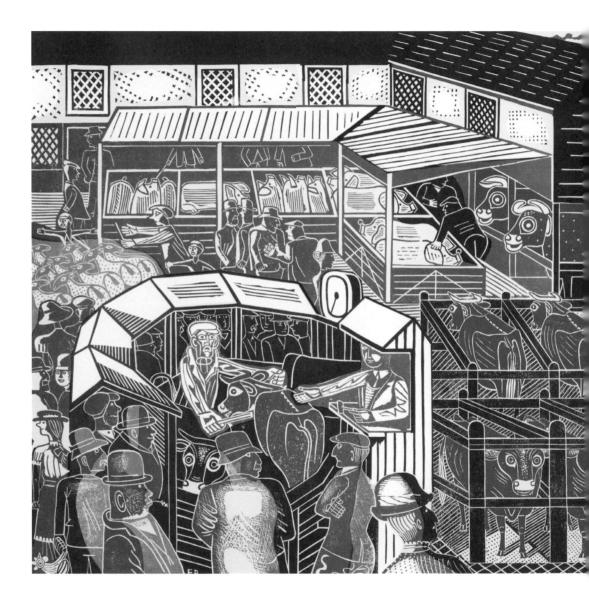

Markets were a favourite subject for Bawden, and so were architectural structures with their inherent patterns of repeated horizontals and verticals. In *Cattle Market*, the bustling activity is regulated by the rows of cattle stalls and pens. Even the backsides of a flock of sheep become a repeat motif. With just three bold colours, plus black and white, Bawden emphasized certain features and neatly differentiated cattle, sheep and humans. This print was published as a lithograph (reproduced from an original linocut) for the innovative Contemporary Lithographs scheme, which was designed to bring affordable art to the general public.

39. *Cattle Market* published by
Contemporary Lithographs Ltd, 1937
Colour lithograph after linocut original
Victoria and Albert Museum, London
(V&A Circ.136-1939)

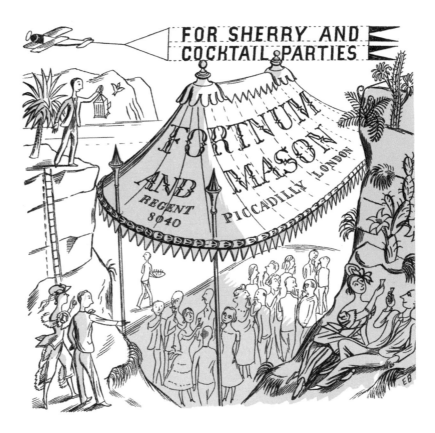

40. *For Sherry and Cocktail Parties*, cover
to brochure issued by Fortnum & Mason,
1937
Line block
Victoria and Albert Museum, London
(NAL 38041800554792)

Bawden worked for Fortnum & Mason over a period of
25 years, illustrating seasonal brochures for Christmas and
Easter, and others advertising food and drink for parties.
This monochrome design was one of his more restrained
efforts, lacking the humorous high jinks that came to
characterize his Fortnum's style.

GOOD DRINKS

Ambrose Heath

LONDON
FABER & FABER LTD.

41. Title page to Ambrose Heath, *Good Drinks*, published by Faber & Faber, 1939
Line block
Victoria and Albert Museum, London
(NAL 38041989072749)

For the cover of *Good Drinks*, Bawden drew a glass of Pimm's, with blue borage flowers and bottles in a cooler, and on the title page, a glass of wine stands beside two faceted stoppers for bottles or decanters. Bawden suggests that this is an instance of drinking al fresco – 'on the shady verge of the tennis court', as described in Heath's foreword – by his inclusion of a perky fly perched on the rim of the glass.

42. *Kew Gardens*, 1939, proof before
lettering of a poster issued by the
London Passenger Transport Board
Colour lithograph
Victoria and Albert Museum, London
(V&A E.422-1981)
Given by Roderick Eustace Enthoven

Bawden made many illustrations of Kew Gardens, a place he
found endlessly fascinating and was inspired by throughout his
life (see also 16–19, 31). He composed this design by combining
pieces of cut and torn paper with linocut printing to make a
collage that was reproduced as a lithograph. It features two
of Kew's most famous sights: the great iron-and-glass Palm
House and the Pagoda. The scene is playful and ambiguous,
and the flamboyant cacti in the foreground look rather like
visitors wearing exotic hats.

43. *Grass and Swan*, wallpaper,
produced by Cole & Son Ltd, 1938–9
Colour print from lino blocks
Victoria and Albert Museum, London
(V&A E.1634-1939)

One of the *Bardfield Wallpapers*, a range produced by Cole &
Son with patterns by Bawden and his neighbour John Aldridge,
Grass and Swan is more restrained than his earlier designs.
The motifs are reminiscent of his illustrations for books and
advertisements, having the simplicity of line drawings
and being printed in delicate, subdued colours. This design
was produced in several colourways, whereas Bawden's
earlier papers were produced in a single colourway.

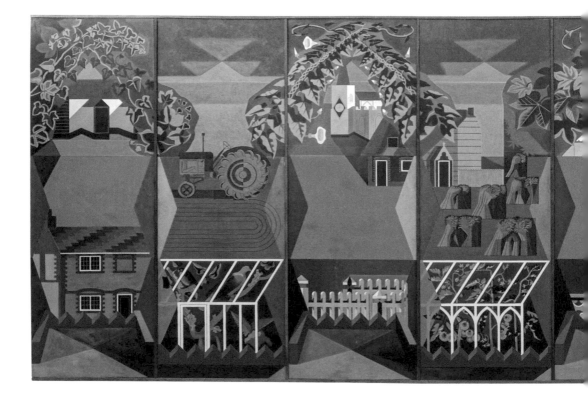

44. *English Garden Delights*, mural
designed for the Orient Line, 1946
Oil on wood panels
Waddesdon Manor, Buckinghamshire
(Rothschild Family)
(Acc. no. 95.1998)

Also known as *The County of Essex in the Autumn*, this
is a celebration of English gardens, from the suburbs to
the shires. It is an impressive composition, employing
several perspectives in three horizontal registers to create
a disorientating illusion of three dimensions. A swag of
foliage – holly, ivy and white-flowered convolvulus among
them – crowns each panel; in the middleground rural life

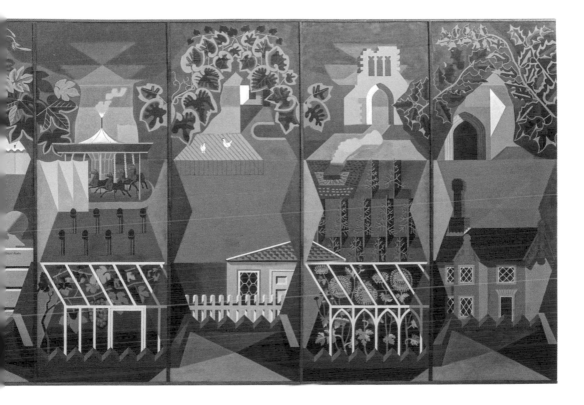

is represented by ploughing, harvesting and a fairground
with carousel and coconut shy; and below, in a series of
greenhouses, we see chrysanthemums (foreshadowing
'The Market Gardener' illustration in *Life in an English
Village*, 54), grapevines and tomatoes (**see** *Autumn*; **61**).
The mural was commissioned by the Orient Line for the first-
class lounge of its new liner, the SS *Orcades*, launched in 1947.

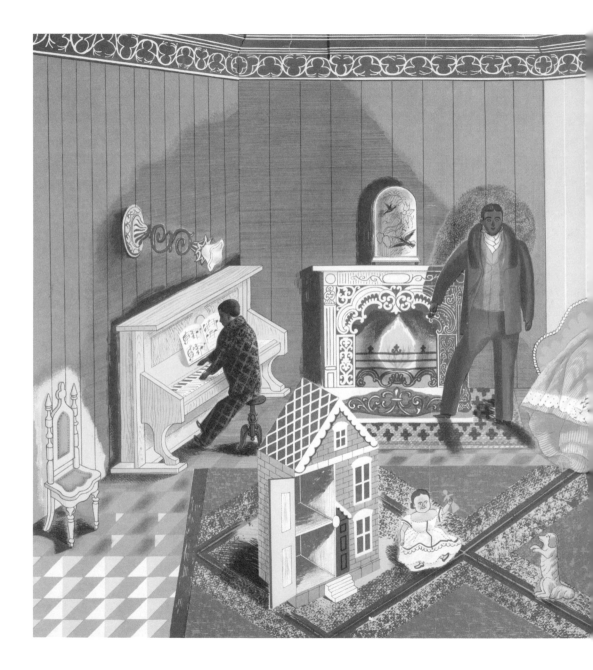

The caterer J. Lyons & Co. was established in 1894 and quickly became an English institution, famous for its chain of tea houses and popular restaurants. It commissioned leading artists of the day to produce a series of lithographs to be installed in all its tea shops, which were rather shabby in the immediate post-war period and needed some cheering decor. Bawden's contribution was this view of the oddly skewed interior of a doll's house, populated by strangely flattened figures. The grimacing doll-child in the foreground is dwarfed by her own doll's house. There is an air of faded Victoriana to the muted off-kilter colours, the furnishings and the dolls' costumes, a reflection of Bawden's own taste, and of a particularly English style. This print was a rare instance of Bawden drawing directly on to the lithographic plate, rather than handing over his collage original to a commercial printer to be reproduced. There is evidence that he made a number of changes to the design in the process.

45. *The Dolls at Home*, published by J. Lyons & Company Ltd, 1947
Lithograph
Victoria and Albert Museum, London
(V&A E.691-1947)
Given by Messrs J. Lyons & Co. Ltd

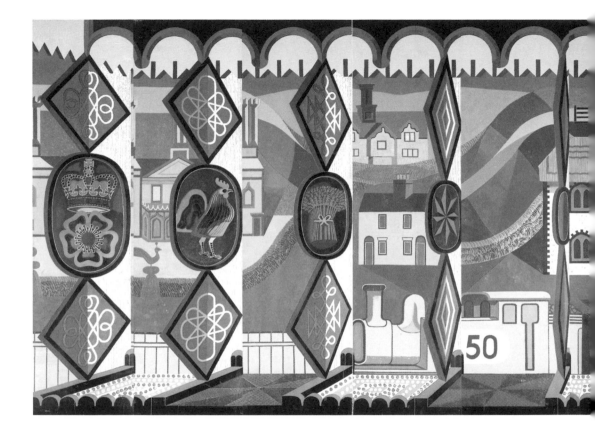

Bawden made three murals – two for the Orient Line and
one for the Festival of Britain – in which he celebrated
Englishness in a post-war spirit of nostalgia and affection
for rural life and country pursuits. This one was commissioned
for the first-class lounge on the passenger liner SS *Oronsay*.
Rendered in cheerful, sunny colours, it comprises 11 vertical
panels showing an old-fashioned steam locomotive passing
a sequence of pubs, each identified with a bold pictorial

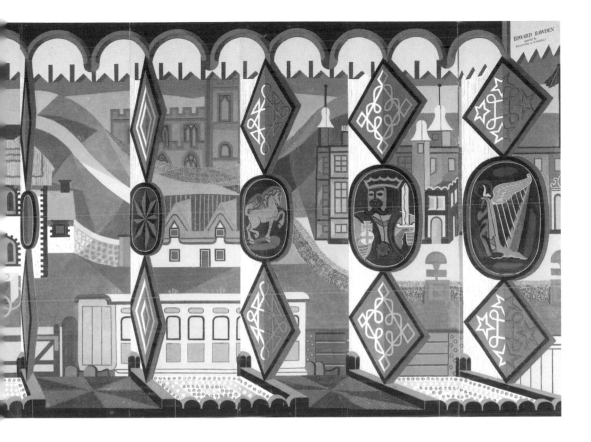

sign – including the Rose and Crown, the Wheatsheaf, the Elephant and the King's Head. Seen beyond and between are stately homes and cottages, hedges and topiary, and a single figure at the centre: an ice-cream seller on his 'Stop Me and Buy One' tricycle. The English theme was emphasized in the decorations of the SS *Oronsay*, which sailed originally between the United Kingdom and Australia via the Suez Canal.

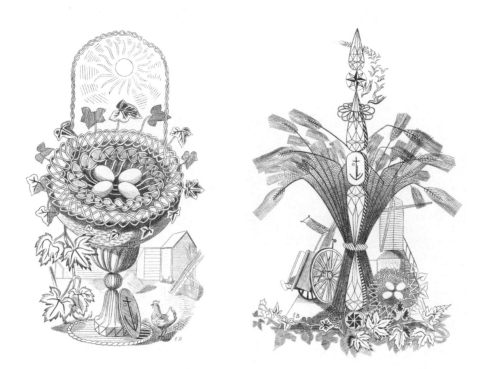

47. Menu cards for the Orient Line, 1949
Engravings
Victoria and Albert Museum, London
(V&A E.754 and 755-1949)
Given by Sir Leigh Ashton, FSA

These finely detailed menu designs were printed for a dinner on 19 September 1949, on board SS *Orcades*. Both are charming vignettes alluding to food and farming, with motifs drawn from Bawden's life in rural Essex. In one we see a clutch of eggs nestled in a filigree basket set on a garden urn; a chicken and farm sheds complete the scene. The other has as its centrepiece a sheaf of wheat or barley framing a corn dolly, with a nest of eggs, a farm cart and a traditional post mill beyond. Both scenes contain garlands of ivy and vine leaves, and the Orient Line's anchor logo.

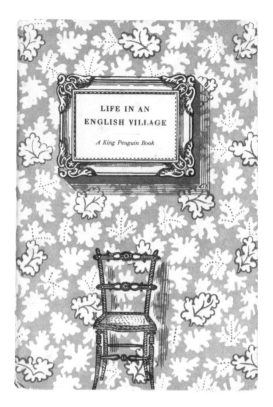

48. Front cover to *Life in an English Village*, published by Penguin Books, 1949
Letterpress
Victoria and Albert Museum, London
(NAL 38041989014964)

With its foliage-patterned wallpaper, old-fashioned rush-seat chair and elaborate picture frame containing the title, this book cover suggests the interior of a late Victorian parlour. This was no doubt deliberate, since Bawden's illustrations show that village life as he knew it in Great Bardfield had changed little since the turn of the century. Both chair and frame have printed shadows to give the illusion of three dimensions.

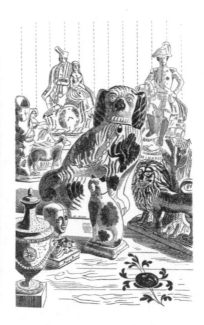

49. 'Staffordshire Figures',
illustration to *Life in an English Village*,
published by Penguin Books, 1949
Line block
Victoria and Albert Museum, London
(NAL 38041989014964)

50. 'Teapots', illustration
to *Life in an English Village*,
published by Penguin Books, 1949
Line block
Victoria and Albert Museum, London
(NAL 38041989014964)

These are two of the six black-and-white prints that
are interspersed in Noel Carrington's introductory essay.
They reflect Bawden's abiding interest in Victoriana, and in
particular the kind of modest ornament and everyday utensil
that he collected and lived with. Some of these – a teapot
and assorted ceramics – can be seen in the photograph of
Bawden in his sitting room taken some years later (**fig. 8**).
The teapots, in various sizes, shapes and styles, are set out in
rows in the manner of museum exhibits, but the Staffordshire
figures, including Napoleon, a shepherdess and a phrenological
head, presided over by a dog, a lion and a disdainful cat, are
presented as an artful junk-shop jumble.

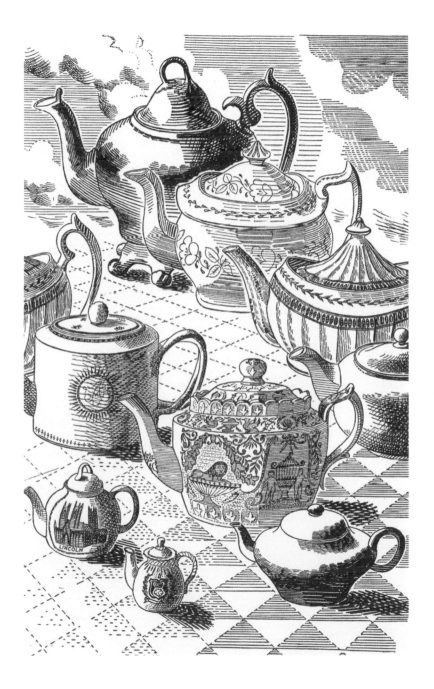

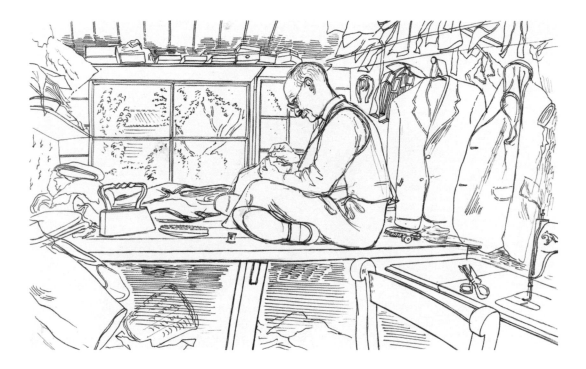

51. *The Tailor*, 1948
Pen and ink
Victoria and Albert Museum, London
(V&A Circ.286-1958)

Bawden made sketches in preparation for the lithographed illustration to *Life in an English Village*. He always preferred to draw in pen and ink; he felt it produced a greater fluency and confidence than pencil. Several of the illustrations to the book show the craft skills that were so important for a thriving rural community; as well as Mr Suckling the tailor, we see the saddler (mending shoes), a workshop with agricultural machinery under repair, and the cabinetmaker's workshop, where one of the men is making a picture frame, probably for Bawden or one of the other artists living in the village.

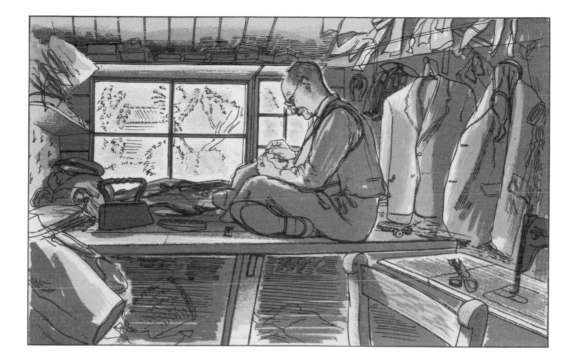

52. 'The Tailor', illustration to
Life in an English Village, published
by Penguin Books, 1949
Colour lithograph from six
hand-drawn zinc plates
Victoria and Albert Museum, London
(NAL 38041989014964)

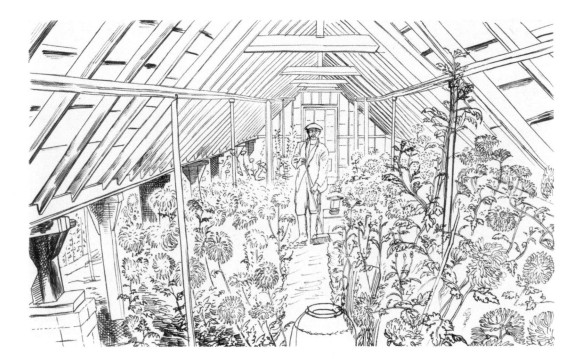

53. *The Greenhouse*, drawing, 1948
Pen and ink
Victoria and Albert Museum, London
(V&A Circ.287-1958)

Here we see Bawden's original drawing and the published
illustration for the plate titled 'The Market Gardener' in
Life in an English Village. Bawden, a keen gardener, had made
a watercolour in 1932 showing what appears to be the same
greenhouse, full of cucumber plants, but in this interpretation
we see rows of mop-headed chrysanthemums.

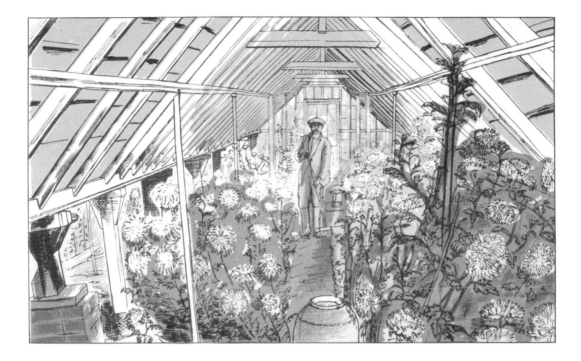

54. 'The Market Gardener', illustration
to *Life in an English Village*, published
by Penguin Books, 1949
Colour lithograph from six
hand-drawn zinc plates
Victoria and Albert Museum, London
(NAL 38041989014964)

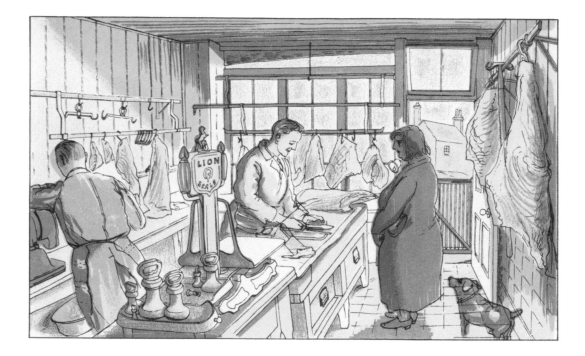

55. 'The Butcher's Shop', illustration
to *Life in an English Village*, published
by Penguin Books, 1949
Colour lithograph from six
hand-drawn zinc plates
Victoria and Albert Museum, London
(NAL 38041989014964)

The customer seen here in the butcher's shop (owned by the
aptly named Mr Bones) has been identified as Daisy Letch,
Bawden's cleaner at the time. Aside from the old-fashioned
set of scales prominent on the counter in the foreground,
this village butcher's shop of the period is not so very
different from a local butcher today.

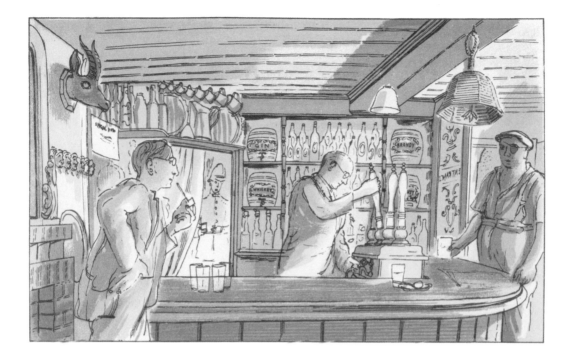

56. 'The Village Pub', illustration
to *Life in an English Village*, published
by Penguin Books, 1949
Colour lithograph from six
hand-drawn zinc plates
Victoria and Albert Museum, London
(NAL 38041989014964)

Leaning on the bar of the Bell, pipe in hand, we see the artist
John Aldridge, Bawden's next-door neighbour. The other
customer, a working man in flat cap and overalls, is Fred
Mizen, a gardener who worked for both Aldridge and Bawden.
Before World War I Mizen had been a farm labourer, and
this may be where he learned to make corn dollies, which are
decorative figures of twisted straw traditionally made from the
last sheaf of corn at harvest time; the straw bell shown hanging
over the bar is an example of his work.

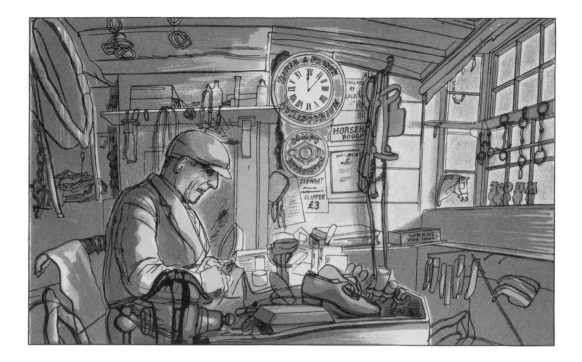

57. 'The Saddler's Shop', illustration
to *Life in an English Village*, published
by Penguin Books, 1949
Colour lithograph from six
hand-drawn zinc plates
Victoria and Albert Museum, London
(NAL 38041989014964)

In a workshop dominated by a handsome gilded clock, the
saddler is shown at work on shoe repairs. This was perhaps
a useful sideline, suited to his skill with leather in the making
of saddles and harnesses. All scenes in *Life in an English Village*,
showing local shops and artisans, focus on the crafts that were
so important to the functioning of a rural community.

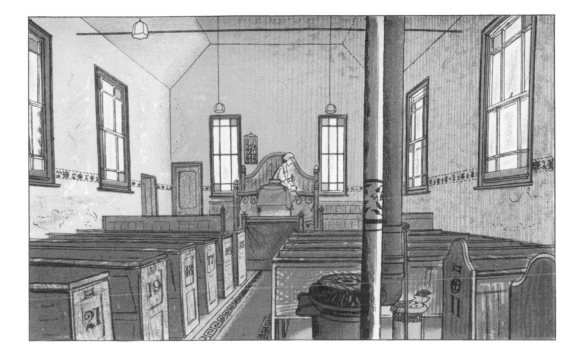

58. 'The Methodist Chapel', illustration
to *Life in an English Village*, published
by Penguin Books, 1949
Colour lithograph from six
hand-drawn zinc plates
Victoria and Albert Museum, London
(NAL 38041989014964)

The Methodist chapel is a stark contrast to the parish church
also illustrated in the book. It is plain and serviceable;
the heating boiler and its flue dominate the foreground,
and the only ornaments are the small squares of coloured
glass at the corners of the windows, and a narrow band of
simple stencilled decoration running around the walls.
At the far end the small figure of a cleaner is just visible,
dusting and polishing the woodwork.

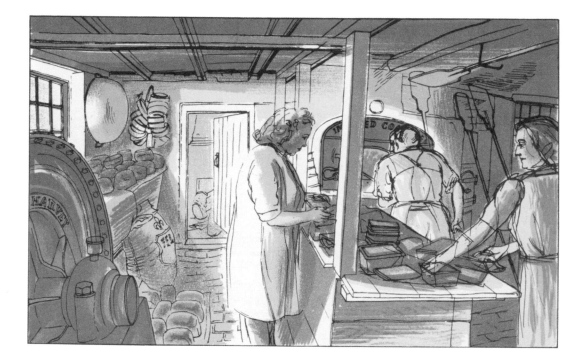

59. 'The Baker', illustration to
Life in an English Village, published
by Penguin Books, 1949
Colour lithograph from six
hand-drawn zinc plates
Victoria and Albert Museum, London
(NAL 38041989014964)

The book was printed by the Curwen Press, where Bawden
drew the colour separations for these illustrations in pen, brush
and crayon directly on to the zinc plates. The compositions,
outlined in black and filled with loose colour washes, have the
freshness and liveliness of his post-war work in watercolour.
Bawden conjures the warm fug of the bakery using only
a handful of colours, from the golden tints of the freshly baked
loaves to the flushed cheeks of the bakery workers.

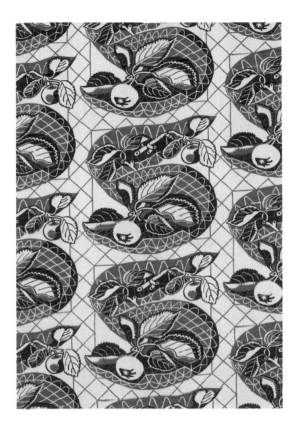

Gerald Holtom (1914–1985) was a designer and artist who
commissioned a number of leading artists and textile designers
in the 1940s and 50s to produce designs for his company.
This screen-printed canvas was designed to be used
for proscenium curtains for a number of new schools in
Hertfordshire. This probably explains why the motif of cherries
set against a wire trellis is bolder than most of Bawden's repeat-
pattern designs. It has some similarities to the boldly drawn
fruit in the linocut *Autumn*, made the same year (61).

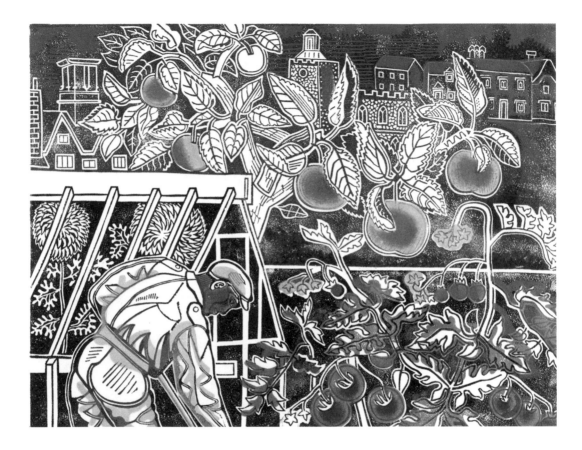

61. *Autumn*, 1950
Colour linocut
Victoria and Albert Museum, London
(V&A Circ.225-1950)
Given by the Trustees of the Giles Bequest

The V&A commissioned this print with funds from the Giles Bequest, established in 1939 'for the encouragement of relief-printing in colour'. In style and subject, it echoes Bawden's mural *English Garden Delights*, on which he was working at the same time (44). Again, it is a local scene, with a view of Great Bardfield in the background. A two-block linocut with overprinting and stippling, it is notable for a sparing use of colour, some deliberately mis-registered.

62. *Farmyard*, woven by the Edinburgh
Tapestry Co. Ltd, 1950
Wool tapestry
Victoria and Albert Museum, London
(V&A T.273-1978)

In a charmingly stylized farmyard scene Bawden brings together
several of his favourite subjects: cows (or perhaps bullocks; they
all have horns, but at least one has an udder), chickens and a tail-
less turkey. The scene is framed by abstract heraldic-style motifs
in roundels. Bright colours are modified by the subtle blending
of one into another, evidence of both the precision of Bawden's
preliminary design and the skill of the weavers at Dovecot
Studios in Edinburgh, where the tapestry was made.

'Pair posters' like this –
designed in two halves,
one for the image and the
other for text – were intended
for prime sites, such as
London Underground
station entrances. The format
offered more freedom for
both artist and copywriter.
The main image is a collage
of architectural elements,
taken from City landmarks,
which echo and repeat. The
buildings include 'bits and
pieces' of the Old Bailey,
the Monument to the Great
Fire of London, St Paul's
Cathedral, Tower Bridge,
Mansion House, the Guildhall
and Leadenhall Market, as
well as 'a typical old-fashioned
street lamp, a bollard & other
things of that sort'.[34] The
only reference to London
Transport in the picture sheet
is a subtle detail at the bottom,
where the eye of the plump
pigeon has been replaced
with the logo of the London
Underground network.

CITY

stone and city brick is London's history for all to see. You can see the City best when its workday inhabitants have deserted it. On a Saturday afternoon or Sunday Wren and his peers are very much alone in their glory. There is time and space to stand and admire, to snap or sketch, to look above the busline, and in one small square mile seek and find treasure which The Bank can never value . . .

Some suggestions for Citygoers (who may or may not know their City)

ALL HALLOWS BARKING BY THE TOWER
A pre-Great Fire Church, now the shrine of Toc H's parent Lamp of Maintenance. Its crypt museum takes you back to Roman and Saxon London.
District and Circle Lines to Tower Hill.

ST. BARTHOLOMEW THE GREAT
Outside the Tudor gatehouse the boy King Richard II faced the Peasants' Revolt in 1381. The Church has London's finest Norman interior with a charming 13th-century Lady Chapel and the tomb of Rahere, the 12th-century founder of 'Bart's' Hospital over the way.
Circle and Metropolitan Lines to Aldersgate (closed on Sundays) or Farringdon; or Central Line to St. Paul's.
Bus 4A to Aldersgate Station; bus 63 or Holborn Circus trolleybuses to Charterhouse Street; trolleybuses 167, 677, 679 to Smithfield ; or buses along Holborn Viaduct to Old Bailey.

GOUGH SQUARE
The City as it was in the 18th century. At No. 17 is the attic study where Dr. Johnson compiled much of his Dictionary. 'When a man is tired of London' said the Doctor, 'he is tired of life'.
Open weekdays from 10.30 a.m. to 4.30 p.m. from September to April. Closed Sundays and Bank Holidays. Admission 1/-.
District and Circle Lines to Blackfriars, or Piccadilly Line to Aldwych (closed on Sundays).
Through Hind Court from Fleet Street.
Buses along Fleet Street to the Daily Telegraph building.

GUILDHALL
The war-battered 15th-century Great Hall is still worth seeing, and the Eastern Crypt is a fine example of groined vaulting. The Museum is rich in City antiquities, the Library in London prints, and there is usually an exhibition in the Art Gallery.
Open Mondays to Fridays from 10 a.m. to 5 p.m., Saturdays 10 a.m. to 4 p.m. Closed Sundays. Admission free.
Central and Northern Lines to Bank, or District and Circle Lines to Mansion House.
Buses along Cheapside or Moorgate.

ST. MARY-LE-BOW
Having admired Wren's loveliest spire turn west and capture (while you can) a view of St. Paul's revealed by the blitz that destroyed those 'Bow Bells' which used to define the true cockney.
District and Circle Lines to Mansion House, or Central and Northern Lines to Bank.
Buses along Cheapside.

THE MONUMENT
To see Wren's spires to perfection climb the 311 steps inside the Monument. It was erected to a modified Wren design to commemorate the origin of the Great Fire (1666) in Pudding Lane nearby.
Open weekdays 9 a.m. to 4 p.m., from October to the end of March. Closed Sundays. Admission 6d.
District and Circle Lines to Monument (escalator connection from Central and Northern Lines at Bank).
All buses which cross London Bridge.

THE ROYAL EXCHANGE
Walk on the stones trod by its Elizabethan founder, Sir Thomas Gresham (whose grasshopper surmounts the eastern cupola), and study London's history in the paintings along the arcaded walls.
Open Mondays to Fridays from 10 a.m. to 3 p.m., Saturdays from 10 a.m. to midday. Admission free.
Central and Northern Lines to Bank (escalator connection from District and Circle Lines at Monument).
Buses to The Bank.

THE TEMPLE
Read the history of the Knights Templar, go hand in hand with Elia, stroll the Georgian terraces and feed the birds in Fountain Court, but be sure to go inside Middle Temple Hall—the Elizabethan screen, the original glass and Drake's table survive.
Open Mondays to Fridays from 10 a.m. to midday and from 3 p.m. to 4.30 p.m., on Saturdays from 10 a.m. to 1 p.m. Closed Sundays. Admission free.
District and Circle Lines to Temple, or Piccadilly Line to Aldwych (closed on Sundays).
Buses along Fleet Street or Victoria Embankment.

THE TOWER
There is more, far more, here than the Regalia and the Bloody Tower which were your delight as a child. This time you can admire the exquisite Norman Chapel of St. John, study one of the best Armouries in England, and enjoy London's River from the Terrace.
Open on weekdays from 10 a.m. to 4 p.m. from October to April. Closed on Sundays. Admission 1/-, Children 6d. Free on Saturdays and Bank Holidays.
District and Circle Lines to Tower Hill.
Buses 42, 78 to Tower Gardens.

by LONDON TRANSPORT

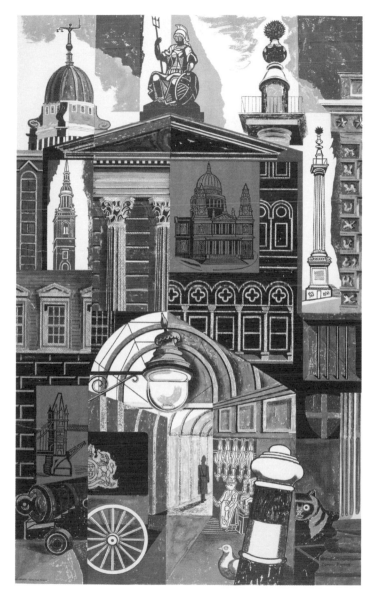

63. *City*, poster issued
by London Transport, 1952
Colour lithograph and letterpress
Victoria and Albert Museum, London
(V&A E.1817, 1817A-1952)
Given by the London Transport Executive

64. Plate from the Heartsease dinner
service, made by Josiah Wedgwood &
Sons Ltd, Etruria, for the Orient Line,
1952
Bone china with lithographic transfer-
printed decoration
Victoria and Albert Museum, London
(V&A Circ.329-1955)
Given by the Orient Line

In addition to designing murals, curtain fabrics and menu cards,
Bawden was commissioned to design a dinner service for use on
board the Orient Line ships. Titled Heartsease, the service was
decorated with a simple pansy (heartsease) motif at the centre,
framed by stylized petals and a border of flowers and leaves, all
printed in mauve and grey. This modest plant, a favourite in
cottage gardens, continued the theme of English rural life that
characterized all Bawden's designs for the Orient Line.

65. *The Bird's Nest*, 1951
Watercolour
Fry Art Gallery, Saffron Walden
(PC 1690)
Purchased with assistance from
the Victoria and Albert Museum
Purchase Grant Fund

Bawden found many subjects close to home, and several of
his pictures are views from the upper storeys of Brick House,
Great Bardfield, where he had lived since 1931. Here we look
down into the back garden at a bird's nest in a leafless, thorny
tree. This is a later version of a near-identical composition
dated 1948. Bawden was devoted to his garden; in letters
to friends he gives progress reports on seeds and cuttings
exchanged, and many of his pictures reflect his interest in
the structure of trees and plants.

66. Design for department-store
decoration, *c.*1953
Pencil, watercolour and bodycolour
on paper
Victoria and Albert Museum, London
(V&A E.440-2010)

In collaboration with Richard Guyatt (then professor of graphic
arts at the RCA), Bawden designed a decorative scheme for
the facade of the department store Selfridges, on London's
Oxford Street, to celebrate the coronation of Queen Elizabeth
II in June 1953. The designs include various emblems of Great
Britain: Britannia presides over two figures hauling in a net
teeming with fish; above her are a jewelled crown, a sunburst
and winged trumpeters, with flocks of doves. The heads of
lions and unicorns – heraldic symbols of the United Kingdom
– alternate on pilasters garlanded with swags of red, white and
blue. The scheme was not realized, and a more conventional
decoration by another designer was used instead.

With its echoes of Bawden's poster from 1925 showing the Changing of the Guard (6), this print was commissioned by the RCA for a portfolio to celebrate the coronation of Elizabeth II. It is one of the few editioned lithographs the artist produced. Here he delights in the repeated heads and helmets, collars and capes of the mounted troops of the Queen's Life Guard, bringing a vivacious energy to what could have been a rather static subject.

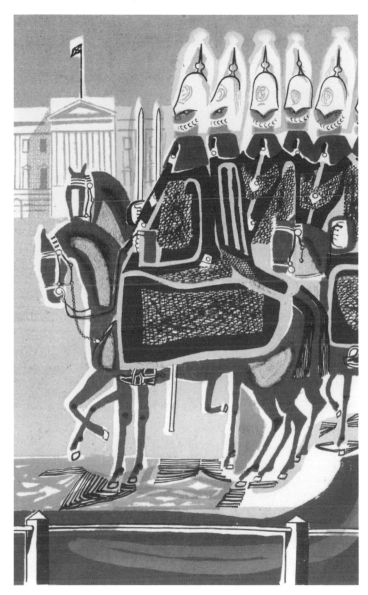

67. *Life Guards*, 1953
Colour lithograph
Victoria and Albert Museum, London
(V&A Circ.326-1953)

The Titfield Thunderbolt (1953), filmed at Ealing Studios
in west London, was one of the so-called Ealing Comedies,
known for their good-hearted, quirky British humour.
Directed by Charles Crichton, the story centres on a group
of villagers trying to save their railway branch line from
closure, using an antique steam locomotive. Bawden's design,
hand-drawn in coloured crayons and watercolour (and then
reproduced lithographically), was deliberately gauche, reflecting
the ideas of enthusiastic amateurism and affectionate nostalgia
conveyed in the film. This illustrative 'picture-book' style is
completed by the odd mix of typography, and the way in which
the smoke billowing from the engine was adapted to frame
the title and the hand-drawn names of the cast.

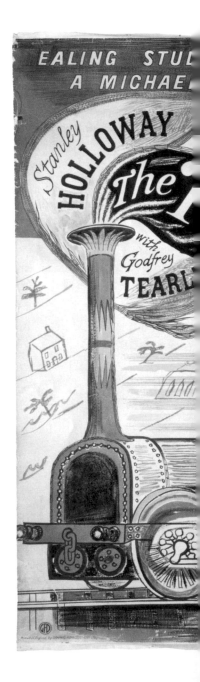

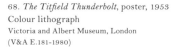

68. *The Titfield Thunderbolt*, poster, 1953
Colour lithograph
Victoria and Albert Museum, London
(V&A E.181-1980)

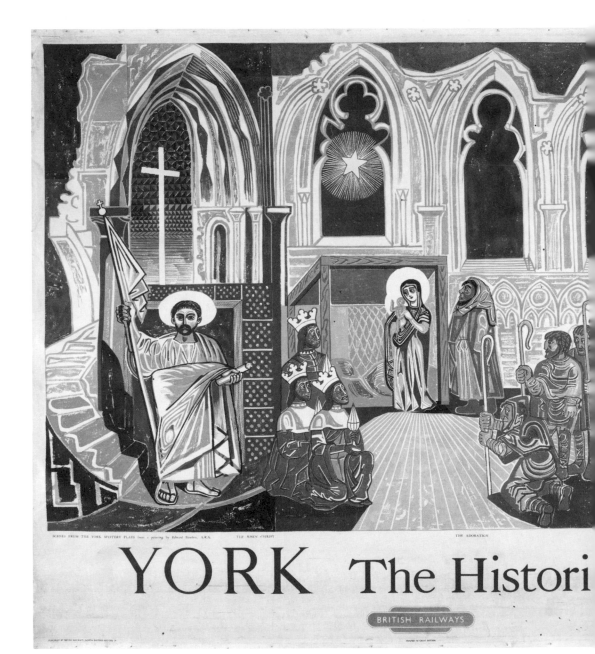

SCENES FROM THE YORK MYSTERY PLAYS from a painting by Edward Bawden, A.R.A. THE RISEN CHRIST THE ADORATION

YORK The Histori

PUBLISHED BY BRITISH RAILWAYS NORTH EASTERN REGION 75 PRINTED IN GREAT BRITAIN

This poster advertises performances of the traditional medieval mystery plays staged in the ruins of St Mary's Abbey, York, in June and July 1954. Originally a set of 48 plays, performed by the Guilds of York, they illustrate a Christian history of the world from the Creation to the Last Judgment. Having lapsed for several centuries, the performances were revived in 1951 and became an important tourist attraction for the city, staged on a three-year cycle. Bawden's poster, with figures represented in a mock-medieval style, shows three scenes from the plays: The Risen Christ, The Adoration, and Satan at Hell's Mouth.

69. *York: The Historic City*, poster, issued by British Railways, 1954
Colour lithograph
Victoria and Albert Museum, London
(V&A F.189-1980)

70 Oronsay, furnishing fabric
produced by Gerald Holtom Ltd, 1954
Screen-printed linen
Victoria and Albert Museum, London
(V&A Circ.195-1955)
Given by the Orient Line

Bawden designed two furnishing fabrics for the Orient Line,
one for the SS *Oronsay* and another for the SS *Orcades*.
The Oronsay design, with its wavy stripes of sea/sky blue
and its climbing vines in light green on white, is fresh and
simple, echoing the bright holiday spirit of his murals for
the ships (44, 46).

71. *Brick House, Great Bardfield*, 1955
Watercolour
Fry Art Gallery, Saffron Walden
(PC 350)
Purchased with assistance from
the Art Fund

Only a handful of Bawden's pictures show the exterior of
Brick House, his home for some 40 years, although he made
several prints and drawings of the garden. In this winter
scene, his children, Richard and Joanna, can be seen playing
on a sledge in the snow. Bawden's abiding interest in pattern
and texture is evident in the carefully delineated brickwork,
the brick-and-corrugated-iron structure to the left and the
ivy leaves on the right.

72. Two-seater bench, 1956
Cast iron
Victoria and Albert Museum, London
(V&A W.8-1986)

73. Design for a cast-iron
single garden seat, c.1956
Watercolour and pencil
Victoria and Albert Museum, London
(V&A E.106-2019)

This sheet shows sketches, projections and details for the Bilston Garden Seat, produced in 1956 by Bilston Foundries in Staffordshire. The idea for a range of cast-iron garden furniture (to include individual seats, a two-seater bench and a low table) came from Robert Harling, a friend of Bawden's who worked in advertising and had previously commissioned him to illustrate the Fortnum & Mason catalogue and the *Wisden Cricketers' Almanack*. The design shows Bawden's innate love of pattern, which was effective here in creating the perforations necessary to produce a structure that was strong but not too heavy. At the centre of the chair back he proposed a 'spider's web' supported at the corners as if suspended from the frame. As built (**see 72**), this was modified into a more conventional hexagonal web motif and used only on the two-seater bench. Bilston's promotional leaflet describes it as 'an ornamental seat unique in its gracefulness'; the advertised price was 18 guineas.

Ives Farm was a favourite local subject for Bawden – it was literally at the end of his garden in Great Bardfield – and the life of the farm and the Ives family recur in his watercolours and prints over a long period. The family also featured (unnamed) in the plate titled 'Sunday Evening', in the book *Life in an English Village* (1949).

74. *Ives Farm, Great Bardfield*, 1956
Colour linocut
Fry Art Gallery, Saffron Walden
(PC 923)
Purchased with assistance from
the Victoria and Albert Museum
Purchase Grant Fund

This twilight view of Great Bardfield was exhibited at the Zwemmer Gallery in London in 1956. A reviewer singled it out for special praise, describing Bawden's innovative approach to linocut as 'deliberately using the medium's natural boldness to do apparently impossible things'.[35] Linocut is best suited to simple shapes and flat areas of colour, but Bawden achieved an extraordinary degree of detail here, and rich contrasts of texture. His interest in architecture and repeated ornamental pattern is obvious, as is his use of shadows for decorative and destabilizing effect. The image is typical of his work, with careful observation modified by an instinct for decorative abstraction and stylization.

75. *Town Hall Yard*, 1956
Colour linocut
Victoria and Albert Museum, London
(V&A Circ.865-1956)

76. *Houses at Ironbridge*, 1956–7
Watercolour and ink on paper
Tate, London
(T00206)

On a working holiday to Ironbridge in Shropshire, Bawden painted a number of watercolours. He recalled, 'I was at Ironbridge for about six weeks in September and October 1956 and was joined by John Aldridge, John Nash and Carel Weight. Each of us in turn painted the famous bridge … "Houses at Ironbridge" was almost the last painting I was able to do during my stay.'[36] In common with so many of his prints and watercolours, this study of the local architecture delights in pattern and texture, seen here in the brickwork on walls and chimneys, and the mottled slate of the roofs against an agitated sky.

77. *Caradon*, 1958
Watercolour
Tate, London
(T00281)

Bawden enjoyed several holidays in Cornwall, where he found
a landscape that was different from the arable fields of Essex.
In the nineteenth century deposits of tin and copper were
mined around Caradon, but the site had been abandoned once
the seams of ore were exhausted. The workings scarred the
land with deep ruts and channels, punctuated by spoil heaps.
This bleak place intrigued him, and he made several paintings
in the area. Of this view, he wrote in April 1958, 'It was painted
in one session, which is not my usual practice, in fact exceptional,
but it was a very cold morning & the weather was uncertain.'[37]

78. *Good Will on Earth to Mice,*
design for a Christmas card, 1983
Linocut with watercolour
Victoria and Albert Museum, London
(V&A E.176-1984)

This design was one of several commissioned by the
V&A from winners of the Francis Williams Prize for
Book Illustration, a competition administered by the museum.
Cats, a perennial Bawden favourite, are shown in playful mode,
peaceably sharing their Christmas cake with a pair of eager
mice. Bawden's lifelong love of cats began with his discovery
of Louis Wain's comical anthropomorphized cats when he was
a child. He later reminisced, 'What lovely cats they were!'[38]

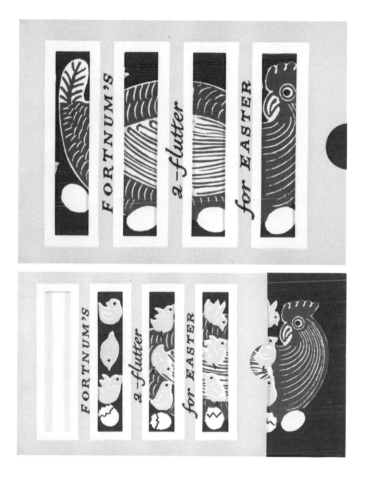

79. Fortnum's a-flutter for Easter, booklet
issued by Fortnum & Mason Ltd,
London, 1958
Colour line block and die-cutting
Victoria and Albert Museum, London
(V&A 38041997104419)

Bawden illustrated several catalogues, brochures and
advertisements for the upmarket grocer Fortnum & Mason.
In this instance the booklet is housed in a die-cut card sleeve
designed to look like a hen coop containing a chicken sitting
on her eggs; as the booklet is removed from the sleeve, the
chicks 'hatch' from the eggs.

Making clever use of a long, narrow format (it is 148 cm/58¼ in. long), this imposing print employs strong verticals in black and white, allied to pattern and repetition, light and shade. Bawden clearly enjoyed the frilly exuberance of the Regency architecture, the curvaceous domes of Brighton Pavilion, which frame the view of the pier, and the echoes of both in the ironwork of the pier itself. He took considerable artistic licence with the composition since, in reality, pier and pavilion are some distance apart. The geometry of the architecture is contrasted with the more delicate, fluid lines of the waves, represented in a style that recalls classic Japanese woodblock prints. This is one of the few prints where Bawden made a second edition; the first was dated 1958 but he reworked the subject, with subtle changes to the colouring, in 1977.

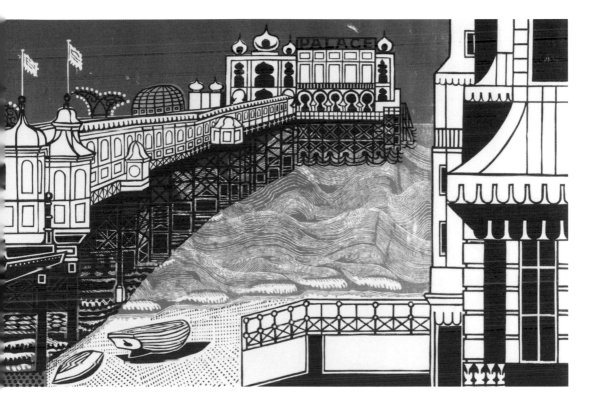

80. *Brighton Pier*, 1958
Colour linocut
Victoria and Albert Museum, London
(V&A Circ.320-1958)

Liverpool Street is the London terminus for trains from rural Essex, and Bawden used the station regularly when he travelled from Great Bardfield. This ambitious linocut was the result of a commission. In an interview for the BBC in 1963 he said, 'I don't think I would have thought of Liverpool Street as a subject, as I am so familiar with it. [It] Almost seems to me an extension of my own house. I think the ceiling is absolutely magnificent, it is one of the wonders of London.'[39] He experimented first with lithography but finally chose to work with lino, despite the challenges of scale and fine detail. The edition of 40 was printed in two batches, in 1960 and 1961. As he explained in a letter to a buyer, the process was 'laborious' because 'each copy is printed by foot!'[40] There is great skill in the colouring, with the steam from the engines represented by overprinting with transparent inks.

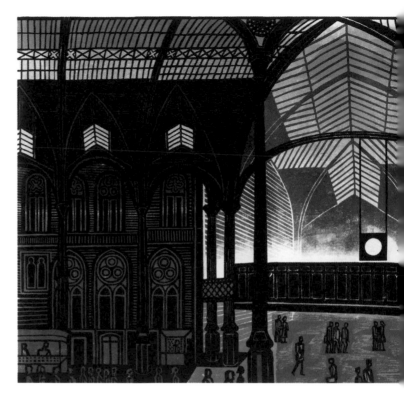

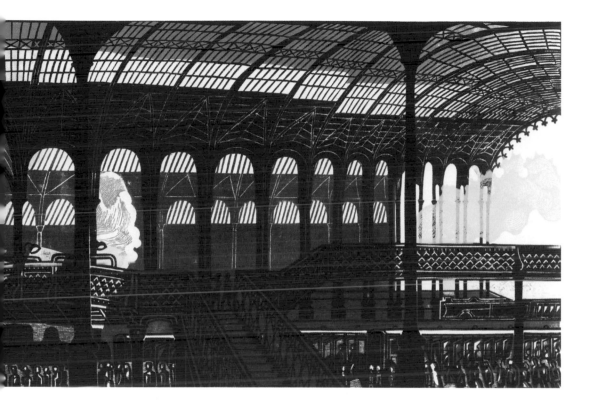

81. *Liverpool Street Station*, 1960
Colour linocut
Victoria and Albert Museum, London
(V&A Circ.422-1960)

This view of St Mary
the Virgin, in the village
of Lindsell, near Great
Bardfield, was Bawden's
largest print, measuring
61 × 155 cm (24 × 61 in.).
Its size and elongated
format were influenced by
his experience of designing
and painting murals. When
working on this scale he had
to print on the floor using foot
pressure, because his printing
press could not accommodate
anything so big. Technically,
it is a tour de force, animated
by white accents representing
the light from moon and
stars; the close-cut lines
give the effect of clouds
racing across the sky, and
fine cutting creates the
impression of light shining
through the yew tree to give
it a shimmering sparkle,
in contrast to the solid
silhouettes of the firs beyond.

82. *Lindsell Church*, 1963
Colour linocut
The Higgins, Bedford
(P.734)

83. *Audley End Park*, *c.*1975
Watercolour
Beecroft Art Gallery, Southend-on-Sea, Essex
(S152)

Bawden painted a series of views of Audley End Park in the mid-1970s and exhibited them at the Fine Art Society in the summer of 1975. In 1973 he had produced a linocut view of Audley End House, which was close to his home in Saffron Walden, and it evidently sparked his wider interest in the park, with its mature trees and landscaped vistas. By this date he had developed distinctive mannerisms, rendering foliage in series of repeating stylized patterns in varying shades of green and blue, and here we see him revelling yet again in the lush verdancy of the Essex landscape.

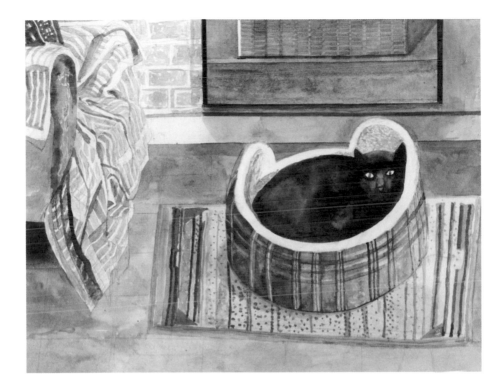

84. *Emma Nelson by the Fire*, 1987
Pencil and watercolour
Tate, London
(T04920)

In his last years at Saffron Walden, being largely housebound, Bawden made watercolours of his home and garden, most of them featuring his cat Emma Nelson. He told an interviewer that he chose to paint whichever spot the cat elected to settle in, and thus 'these paintings are ... the joint creations of cat and artist, Emma and Edward.'[41] This picture also demonstrates his enduring interest in pattern. Bawden explained (in a letter to the Tate) that he liked the patterns for 'their decorative value – also their flattening effect on the <u>form</u>'. The curtain draped over the armchair was by Bawden's friend and former Great Bardfield neighbour the textile designer Marianne Straub.

Notes

1. Quoted in Helen Binyon, *Eric Ravilious: Memoir of an Artist* (Guildford, 1983), p. 133

2. Letter from EB, dated 'August something – 1930', written on Leach Pottery notepaper and addressed jointly to Charles Mahoney, Geoffrey Rhoades and Percy Horton (Mahoney Archive)

3. 'The Montmartre Village', *The Tatler*, 16 July 1958

4. Howes 1988, p. xiii

5. Ibid.

6. Quoted in Paul Huxley, ed., *Exhibition Road: Painters at the Royal College of Art* (London, 1988), p. 20

7. Bilston Foundries advertising leaflet, 1956; quoted in Howes 1988, p. 76

8. Ibid., p. xiii

9. Paul Nash, 'New Draughtsmen', *Signature* (November 1935), no. 1, p. 27

10. Tirzah Garwood, *Long Live Bardfield and Love to You All: Her Autobiography 1908–43*, ed. Anne Ullmann (Upper Denby, 2012), pp. 150–51

11. The London Underground has operated under various titles since the network was established. From 1902 it was known as the Underground Electric Railways Company of London. In 1933, most of London's underground, railways and bus services were merged to form the London Passenger Transport Board, which used the London Transport brand name. The Underground system (also known colloquially as 'the Tube') is now part of Transport for London (TfL), the integrated body responsible for London's public transport.

12. Adrian Bury, 'Water-Colour: The English Medium', *Apollo* (1934), vol.19, p. 85

13. Charles Marriott, 'Art Exhibitions: Mr Edward Bawden', *The Times* (7 October 1933), p. 10

14. Ibid.

15. 'Mr Edward Bawden', *The Observer* (22 October 1933), p. 14

16. Douglas Percy Bliss, 'Art in London, Essex in Watercolours', *The Scotsman* (9 October 1933), p. 15

17. The titles were taken from the works of poets such as Gerard Manley Hopkins, John Clare, George Crabbe and Edward Thomas.

18. Eric Newton, 'Interpretation and Characterisation', *Sunday Times* (6 February 1938)

19. Quoted in Yorke 2007, p. 140

20. Quoted by Brenda Herdman, in *Tribute*, 1992, p. 14

21. 'The lithographs are excellent: all are originals, made direct from the artist's lithographic zinc plates.' Norah Richardson, 'Life in an English Village by Edward Bawden and Noel Carrington', *Journal of the Royal Society of Arts* (16 December 1949), vol. 98, no. 4810, pp. 114–15

22. Edward Bawden, Introduction, in David McKitterick, *Wallpapers by Edward Bawden Printed at the Curwen Press* (Gloucester, 1989), p. 1

23. Quoted in Bliss 1979, p. 165

24. Raymond Mortimer, 'Britain Can Make It!', *New Statesman and Nation* (September 1946), p. 220

25. *Architectural Review* (1952), vol. 112, p. 220

26. Edward Bawden, 'A Note on Lino Cutting', in Bawden 1979, p. 9

27. Bliss 1979, p. 165

28. Quoted in Webb and Skipwith 2016, pp. 62–3

29. *Flower of Cities: A Book of London* (London, 1949), pp. 13–30

30. See http://collections-search bfi.org.uk/web/Details/ChoiceFilmWorks/150162208 (accessed January 2022)

31. Quoted at www.lundhumphries.com/products/edward-bawden-scrapbooks (accessed January 2022)

Picture Credits

32. John Russell Taylor, 'As If through the Eyes of a Child', *The Times* (9 September 1989)
33. Nash, 'New Draughtsmen', p. 26
34. Edward Bawden in a letter to Harold Hutchison, London Transport publicity officer, quoted in Skipwith and Webb 2011, p. 125
35. Eric Newton, 'Round the London Galleries', *The Listener* (19 July 1956), p. 90
36. Quoted in www.tate.org.uk/art/artworks/bawden-houses-at-ironbridge-t00206 (accessed January 2022)
37. Quoted in www.tate.org.uk/art/artworks/bawden-caradon-t00281 (accessed January 2022)
38. Quoted in Howes 1988, p. xi
39. BBC, *Monitor: A Sense of Order*, broadcast 10 November 1963
40. Quoted in catalogue for The Modern Sale, Anderson & Garland, Newcastle, 23 May 2019, lot 144
41. Quoted in *House and Garden* (December 1987)

Selected Bibliography

Edward Bawden, *A Book of Cuts*, with text by Ruari McLean (Aldershot, 1979)

Edward Bawden: The Art of Design, with essays by Kate Hughes, Michael Poraj-Wilczynski and Maurice Whitbread (Canterbury, 1988)

Douglas Percy Bliss, *Edward Bawden* (Godalming, 1979)

Andy Friend, *Ravilious & Co: The Pattern of Friendship* (London, 2017)

Justin Howes, *Edward Bawden: A Retrospective Survey* (Bath, 1988)

Tim Mainstone (ed.), *Away We Go! Advertising London's Transport: Edward Bawden and Eric Ravilious* (Norwich, 2006)

J.M. Richards, *Edward Bawden*, Penguin Modern Painters (Harmondsworth, 1946)

James Russell, *The Lost Watercolours of Edward Bawden* (Norwich, 2016)

James Russell, *Edward Bawden*, (London, 2018)

Gill Saunders and Malcolm Yorke (eds), *Bawden, Ravilious and the Artists of Great Bardfield* (London, 2015)

Peyton Skipwith and James Russell, *Are You Sitting Comfortably? The Book Jackets of Edward Bawden* (Norwich, 2018)

Peyton Skipwith and Brian Webb, *Edward Bawden's London* (London, 2011)

Peyton Skipwith and Brian Webb, *Edward Bawden's Kew Gardens* (London, 2014)

Peyton Skipwith and Brian Webb, *Edward Bawden's Scrapbooks* (London, 2016)

Tribute to Edward Bawden (London: The Fine Art Society, 7-31 July 1992)

Brian Webb and Peyton Skipwith, *Design: Edward Bawden and Eric Ravilious* (Woodbridge, 2008)

Brian Webb and Peyton Skipwith, *Edward Bawden: Design* (Woodbridge, 2016)

Malcolm Yorke: *Edward Bawden and his Circle: The Inward Laugh* (Woodbridge, 2007)

Acknowledgements

I am indebted to the many scholars and curators whose work I have drawn on in the compilation of this book – in particular James Russell, Peyton Skipwith, Brian Webb and Malcolm Yorke, all of whom are duly recognized in the bibliography. I have long been an admirer of Bawden's ambitious and original linocuts and of the playful invention that animates his idiosyncratic wallpaper patterns, so it has been a pleasure and a privilege to explore his life and career in depth. I am especially grateful to all the public institutions and private individuals whose collections have supplied some of the key images here, with a special mention of the Fry Art Gallery and the Bawden family for their generous support of this publication. My thanks also to all those at Thames & Hudson involved in the commission, editing, design and production, including Julian Honer, Melissa Mellor, Avni Patel and Rosie Coleman Collier. I am also grateful to the copyeditor, Rosie Fairhead, and the designer Isa Roldán for their invaluable input. At the V&A I have had the support of colleagues in various capacities. I must thank Claire Allen-Johnstone, Zorian Clayton and Catriona Gourlay for organizing the photography of textiles, prints and books, and Sarah Duncan and the Photo Studio team for producing the excellent new photographs, often at short notice. My editor in V&A Publishing, Karen Fick, has offered invaluable guidance and support, from managing the Excel spreadsheet that defeated my limited digital skills, to identifying copyright holders, tracking down elusive images, securing permissions and diligently editing my draft texts, tactfully nudging me towards clarity and concision.

Author's Biography

Gill Saunders is Senior Curator of Prints at the Victoria and Albert Museum. She has written widely on twentieth-century and contemporary prints, drawings and posters, and is also a recognized authority on such diverse subjects as botanical illustration and the history of wallpaper. She teaches, lectures and broadcasts regularly. Her publications include *Wallpaper in Interior Decoration* (2002), *Prints Now: Directions and Definitions* (2006), *Recording Britain* (2011), *Bawden, Ravilious and the Artists of Great Bardfield* (2015) and *The Poster: A Visual History* (2020).

Front cover image: Detail of *Life Guards*, 1953 (p. 115)
Back cover image: Detail of *Autumn*, 1950 (p. 108)
Opposite title page: Detail of *The English Pub*, 1949–51 (p. 92)
Opposite contents page: Detail of *Tring/Downe/Westerham*, 1936 (p. 79)

First published in the United Kingdom in 2023 by
Thames & Hudson Ltd, 181A High Holborn, London WC1V 7QX
in association with the Victoria and Albert Museum, London

First published in the United States of America in 2023 by
Thames & Hudson Inc., 500 Fifth Avenue, New York, New York 10110

Edward Bawden's England © 2023 Victoria and Albert
Museum, London/Thames & Hudson Ltd, London

Text and V&A photographs © 2023 Victoria and Albert Museum, London
Design © 2023 Thames & Hudson Ltd, London

British Library Cataloguing-in-Publication Data
A catalogue record for this book is available from the British Library

Library of Congress Control Number 2022939491

ISBN 978-0-500-48077-9

Printed and bound in China by C & C Offset Printing Co. Ltd

Be the first to know about our new releases,
exclusive content and author events by visiting
thamesandhudson.com
thamesandhudsonusa.com
thamesandhudson.com.au

V&A Publishing

Supporting the world's leading
museum of art and design,
the Victoria and Albert
Museum, London